IMAGES
of America

BARNSTABLE VILLAGE, WEST BARNSTABLE, AND SANDY NECK

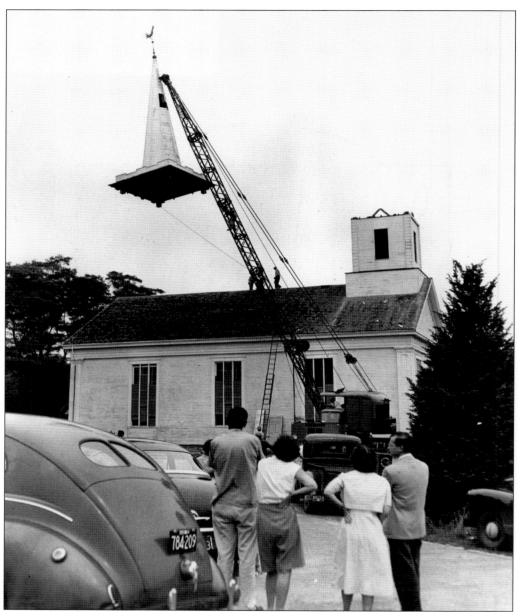

RESTORING THE ROOSTER CHURCH. This is one of a sequence of pictures from the 1958 restoration of the West Parish Church. Why was there a West Parish? Because the congregation of firstcomers brought to Barnstable by Rev. John Lothrop in 1639 had grown, and dissension caused its formal division in 1717 into East and West Parishes. Soon after the split, each parish had its own meetinghouse. The West Parish Church had an earlier facelift, but original structural portions were still intact in 1958, when the extraordinary community effort inspired by Elizabeth Jenkins resulted in the major restoration that makes the church today an architectural gem. Here, the steeple is being gently removed while the ancient rooster holds firm to its perch. More about John Lothrop, Elizabeth Jenkins, and the West Parish Church will be found in the following pages. (Courtesy of the Barnstable Patriot.)

IMAGES
of America

BARNSTABLE VILLAGE, WEST BARNSTABLE, AND SANDY NECK

Edward O. Handy Jr.
for the Sturgis and Whelden Libraries
and the Barnstable Historical Society

ARCADIA

First published 2003
Reprinted 2004

Published by Arcadia Publishing,
an imprint of Tempus Publishing Inc.
Portsmouth NH, Charleston SC, Chicago,
San Francisco

Printed in Great Britain

Library of Congress Catalog Card Number: 2003105123

For all general information, contact Arcadia Publishing:
Telephone 843-853-2070
Fax 843-853-0044
E-mail sales@arcadiapublishing.com
For customer service and orders:
Toll-free 1-888-313-2665

Visit us on the Internet at www.arcadiapublishing.com

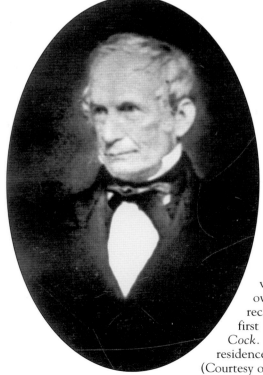

CAPT. DANIEL BACON (1787–1856).
Bacon, who went to sea when he was a
teenager, was first mate of the *Atahualpa* and
played a key role in repulsing the pirate attack
in 1810. He commanded four more China
voyages, became a major Boston shipowner, and
owned some 30 vessels. He was one of the first to
recognize the potential of clippers and one of the
first to own one. His first clipper was the *Game
Cock*. Around 1830, Bacon built his summer
residence (known as the Bacon Farm), near Cobb's Hill.
(Courtesy of the Barnstable Patriot.)

CONTENTS

ACKNOWLEDGMENTS

Help, for which I give hearty thanks, has come from many old and new friends, including those who showed interest, entrusted treasured photographs, and gave welcomed support: Frances Bush-Brown, James Calvin, David Crocker, Jim and Joe Edwards, Christine and John Ehret, James H. Ellis, Jim Ellis, Donald Griffin, Marjorie Handy, John G. Howard Jr., Frances Hunsaker, Jack Hill, Pauline Jarvi, Dan Knott, Tony Lovell, Beatrice Magruder, Betty Nilsson, Duncan Oliver, Michael Walsh, and Martin Wirtanen.

Those who gave generously of their time include Chris Lindquist, Diane Nielsen, Kathy Terkelson, and Janet Lexow of the Sturgis Library; Alexandra Crane and Ann Lawson of the Whelden Library; and Mary Sicchio in the Nickerson Room of Cape Cod Community College. Chris is now at the Westfield Athenaeum, and Janet has moved to the Camden Library.

David Still II, editor of the *Barnstable Patriot,* always found time to answer one more question, to find one more photograph, and to recover the trail of belongings casually deposited in my travels.

Tom Broadrick, Art Traczyk, and Danielle St. Peter were patient during my hours spent reviewing files at the offices of the Historical Commission of the Town of Barnstable.

Also, much gratitude is owed to Amos Otis (my three-times great uncle), Henry Kittredge, Donald Trayser, Mary Sprague, and many others who took the time to commit their knowledge and memories of Barnstable to paper.

Tribute is also due to W.R. Bascomb, Gustavus Hinckley, Robert Redfield, Frank Sprague, and the other early photographers who 100 years ago mastered the cumbersome gear and techniques needed to capture the enticing images of their era, so different from ours.

Finally, I extend thanks to all of the people who contributed to this book, especially my patient and tolerant wife.

INTRODUCTION

Being neither a professional historian nor a scholar, the author has relied extensively on generally accepted secondary sources for historical facts. Original information derives from years of on-site experience, family stories that reach back beyond the author's memory, and the wealth of friends who have shared their own memories, treasured photographs, and family tales. It is hoped that this pictorial history will impart a warmth appropriate to the assembled materials.

The photographs, houses, and buildings do conjure up stories rich in humanity. Some smack of the sea, and some tell of brilliant successes won against heavy odds. Some of the images reveal the newcomer's pride of achievement in this land of opportunity, and many are fragrant with the bloom of youth. Certain of the images raise questions that will never be answered. Others capture vanished industries, the enduring beauty of Sandy Neck, and fleeting pleasures all in an economy and landscape gradually changing with the advent of the railroad, cars, and tourism. While one Cape Codder may have asked, "If it's tourist season, why can't we shoot 'em?" others had found a new way to make hay.

Two historic figures have been slighted. Rev. John Lothrop (1584–1653), born in England and educated at Cambridge, brought his small flock to Barnstable in 1639. A memorial tablet proclaims him "a gentle kindly man beloved by all who knew him." Thomas Hinckley (1620–1706), also English born and there baptized by Reverend Lothrop, came to Barnstable in 1640. Hinckley was twice governor of the Plymouth Colony (1681–1686 and 1689–1692). He was said to be ambitious, able, influential, and a stern Puritan.

Both Lothrop and Hinckley found time for matters other than those of church and state. Both had two wives. Lothrop had 14 children; Hinckley, 16. The author is a 10th-generation descendant of the governor. Assuming that each generation had four producing children, there would be more than one million Hinckley descendants and cousins in the author's generation. Starting with a base of 16 would produce a much bigger cousin population. Apart from what the numbers say about genealogy, they do suggest one cause for our growing population. Resident population in the town of Barnstable has increased from 4,364 in 1900 to 47,821 in 2000 and from 10,480 since 1950. The open fields seen in early photographs are now overgrown and mostly developed. There are times when the benefit of hindsight is questionable.

In any case, please join us on a guided tour of one of the world's most favored places. If you do not find much food for thought along the way, may you find at least a crust, and have a pleasant trip.

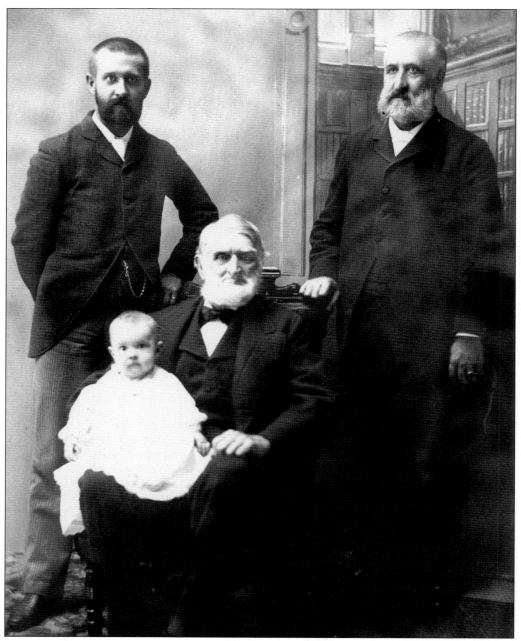

Four Generations of a Barnstable Family, c. 1889. Seated is Capt. Caleb Sprague (1811–1893), and on his lap is Frances Sprague (1889–1891). Standing are Francis Sprague (1862–1945), on the left, and Caleb Sprague (1839–1920). Captain Sprague was a master for over 40 years. Among the vessels he commanded were the brig *Cummaquid* (built in Barnstable), the *North Bend* (owned by Matthew Cobb), the barks *Rosario* and *Chispa,* and the clippers *Gravina* and *Neptune's Car.* Francis Sprague, a Boston lawyer, acted in Barnstable Comedy Club productions and took many of the photographs included in this volume. (Courtesy of James Calvin.)

One

TWELVE MILES BY
HORSE AND BUGGY

All things must have a beginning.

—An old English proverb

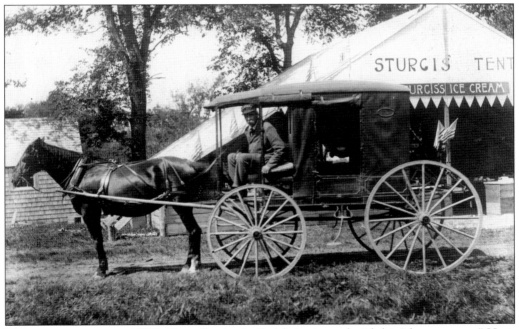

TRANSPORTATION, C. 1890. Cyrus Benjamin Smith is pictured with his "depot wagon." He is at the fair now, but we will ask him to take us by horse and buggy from Yarmouth to Sandwich along the Old King's Highway. We will bump along through Cummaquid, by Cobb's Hill, and through Barnstable Village, Pond Village, and West Barnstable. As the wagon sways, so will we bump around in time a bit. The fare then was cheap, probably only 50¢ per person. The same trip would cost much more today; we would probably have to buy the horse and wagon. (Courtesy of the Sturgis Library.)

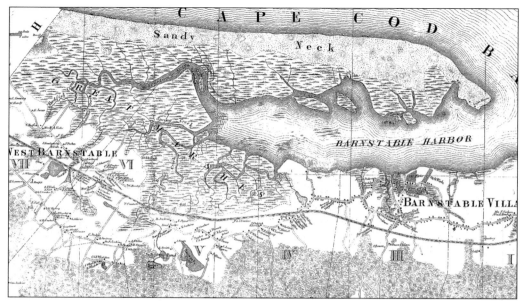

THE 1856 MAP. This map traces the route we will follow from the Yarmouth line on the east to Sandwich on the west and shows the shielding arm of Sandy Neck. You are invited to travel through the following pages and share the unique qualities of these few miles of the New England coast. (Courtesy of John Howard Jr.)

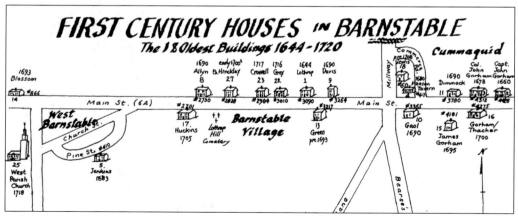

BARNSTABLE'S OLDEST BUILDINGS. James Gould, a retired professor of history and international relations from Scripps College and now an active and well-respected local historian, prepared this schematic map of Barnstable's oldest existing buildings. It has been modified slightly to cover only Cummaquid and the villages of Barnstable and West Barnstable. (Courtesy of James Gould.)

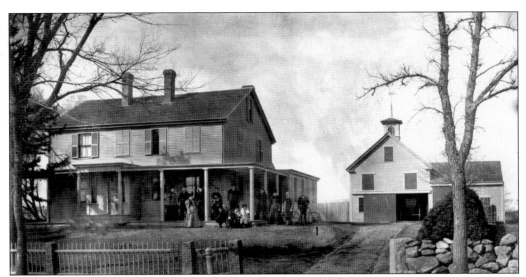

THE CAPT. JOHN GORHAM HOUSE, 4428 MAIN STREET. The plaque in the front yard of this home, one of the most easterly houses in Barnstable, reads, "This house was originally built in 1660 by Captain John Gorham (1621–1676). It was enlarged and remodeled in 1745. Captain Gorham died from a wound received in the 'Great Swamp Fight' in King Philips War." (Courtesy of the Historical Society of Old Yarmouth.)

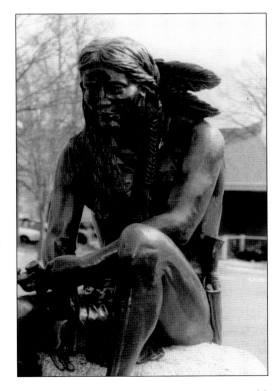

IYANOUGH. Sachem of the eastern part of Sandy Neck and Barnstable, Iyanough helped a 10-man search party from Plymouth recover a boy named John Billington from no fewer than 100 "Nawsett" Indians who could have sought retribution for several members of their tribe sold earlier by an English captain into slavery. Billington was later executed for murder. Iyanough died young from disease contracted while hiding in the swamps and woods from Miles Standish, who had killed several Native Americans believed to have been conspiring against the colonists. The statue, located in Hyannis, is by David Lewis, a local sculptor.

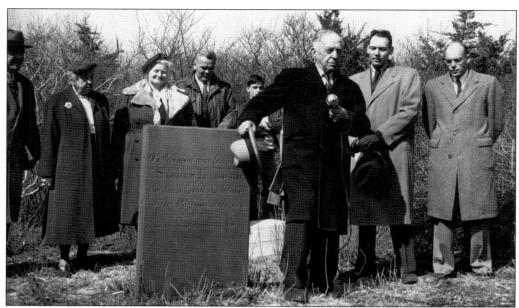

IYANOUGH'S GRAVE. In 1861, Daniel Davis, while plowing his back field in Cummaquid, turned up a brass kettle and underneath it found a sitting skeleton with other relics, including a stone pestle, remains of a bow and arrow, and pieces of wampum. Historians, working from less-than-conclusive evidence, decided that it was Iyanough. The tablet shown here was installed by the Cape Cod Historical Society and marks the burial site on the north side of Route 6A east of Bone Hill Road. Pictured at the dedication in 1957 are, from left to right, George Walsh, Mrs. Walter Baker, Dorothy Worrell, Edward Covell, unidentified, Henry Ellis, Louis Cataldo, and Irving Petou. (Courtesy of the Barnstable Patriot.)

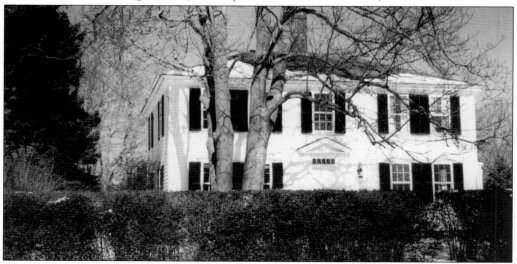

THE JOHN THATCHER HOUSE, 3890 MAIN STREET. In 1779, John Thatcher's will provided that his three daughters, Content, Rebecca, and Mary, have "privileges to live in my east front chamber and wash and bake in kitchen end for as long as they shall live single and no longer." Such multiple ownership in Barnstable houses was common and often continued for several generations.

12

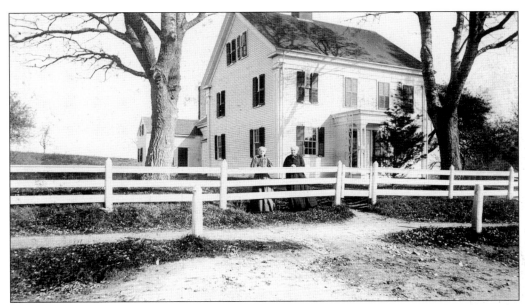

THE ISAAC DAVIS HOUSE, 3688 MAIN STREET. This Greek Revival dwelling dates from the mid-19th century, with earlier portions dating from perhaps the 1790s. It is reputed to have been part of the Underground Railroad. Behind the fence on the left stands Isaac Davis's daughter Mary Freeman Davis (b. 1831). She married Capt. Otis Hinckley. Their only child, Lizzie, lived just over a year. Although Mary Hinckley lived to be 86, surviving her husband by 43 years, family legend has it that she never left her property after his death, not even to dine with relatives next door.

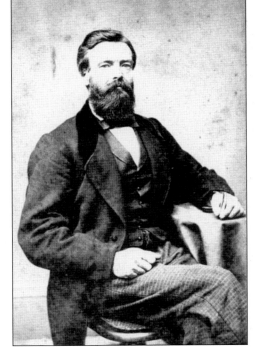

CAPTAIN HINCKLEY. Otis Hinckley was the husband of Mary Freeman Davis. He was born in 1833 and died at age 41. His obituary in the *Patriot* notes, "Formerly one of our most enterprising masters . . . Captain Hinckley was a man of irreproachable character, and affable disposition, and very highly esteemed by all who enjoyed the pleasure of his company." He was a deepwater sailor and participated in the China trade.

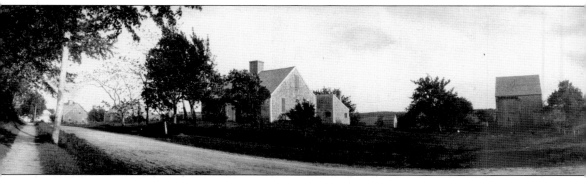

THE AMOS OTIS HOUSE, 3667 MAIN STREET. Built *c.* 1745 by or for Solomon Otis (d. 1778), this house was occupied by Otis's descendants for at least three generations, each with its Amos Otis. Solomon's son Amos (b. 1737) married Catherine Delap, one of the 10 children of James Delap, a fortunate survivor of the ill-fated voyage of the *George and Ann* from Ireland in 1729. The ship, under Captain Rymer, had been chartered to sail with more than 100 passengers and all their money and worldly possessions to Philadelphia so they could resettle in Pennsylvania. Rymer, described as a "cold blooded tyrant," set out to starve his passengers and to steal their wealth by keeping his ship at sea until they died of disease or starvation. Five members of the Delap family succumbed, as did more than half the passengers before the *George and Ann* was forced ashore on Cape Cod. The weakened 14-year-old James Delap managed to crawl to safety. Rymer was later convicted of cruelty to passengers and of an attempt to embezzle their goods and was condemned to be drawn and quartered. The sentence was carried out in Dublin. In 1775, James Delap, a loyalist, moved with his family (except Catherine and her older sister) to Nova Scotia, where he remained until his death at about age 74.

THE FIRST AMOS OTIS. Otis and his brother-in-law Thomas Delap (master of a vessel in the king's service) were shipwrecked on Great Point, Nantucket. The gravestone of Amos reads, "Here lies buried Amos Otis of Barnstable, son of Solomon Otis, Esq. and Jane, his wife. He was cast ashore on Nantucket December ye 6th, 1771, and perished in ye snow storm there aged thirty-four years." One boy survived the beaching. The sea, a good provider, was also a cruel taskmaster.

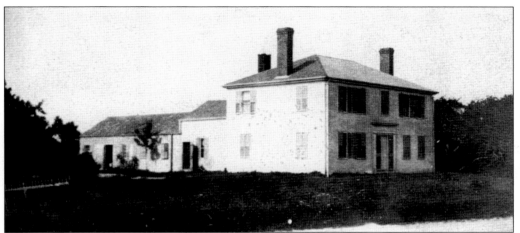

THE BLUE BLIND HOUSE, 3655 MAIN STREET. Built *c.* 1790 probably on land owned by the Otis family, this house was later occupied by Capt. John Otis, his brother Amos Otis Jr., the author, along with their new brides, daughters of their near neighbor, Adino Hinckley. Here is the sad story of Capt. John Otis as written by his grandson Edward Adino Handy in the early 1900s: "My mother, Rebecca, was born there [in the Blue Blind House]. When she was nine months old [in 1829] my grandfather [John Otis], who was a sea captain, was lost at sea, murdered by the mate, it was afterwards believed. . . . Sometime afterward a sea captain who had just returned from China and other foreign ports reported having seen and recognized my grandfather's ship with a different name, and the mate in command." The house was later sold to Capt. Oliver Chase, a deepwater sailor who, according to legend, used blue pigment he brought back from the Orient to paint his wagon and the blinds, which have been painted the same blue since.

GENEALOGICAL NOTES. The third Amos Otis (1801–1875) was cashier of what became the First National Bank of Yarmouth, the first secretary and treasurer of the Barnstable County Mutual Fire Insurance Company, and a director of the Cape Cod Branch Railroad. A prolific writer, he is best remembered for his *Genealogical Notes of Barnstable Families,* an invaluable source of factual information about early days in Barnstable. In his own words, the book is "enlivened with descriptions, narratives and personal anecdotes."

GENEALOGICAL NOTES

—OF—

BARNSTABLE FAMILIES,

BEING A REPRINT OF THE

AMOS OTIS PAPERS,

ORIGINALLY PUBLISHED IN

THE BARNSTABLE PATRIOT.

REVISED BY C. F. SWIFT,

Largely from Notes Made by the Author.

VOLUME I.

BARNSTABLE, MASS.:
F. B. & F. P. GOSS, PUBLISHERS AND PRINTERS.
[THE "PATRIOT" PRESS.]
1888.

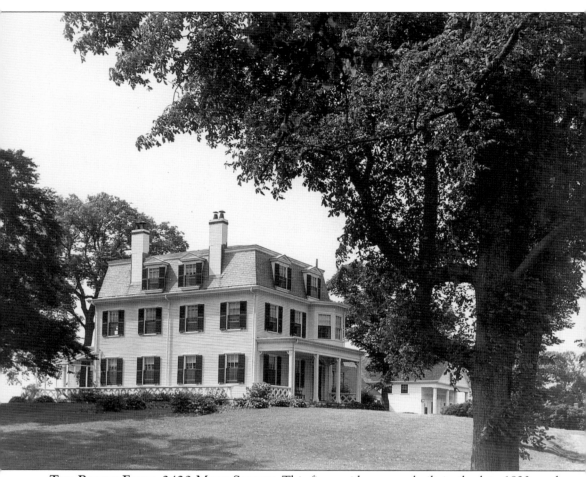

THE BACON FARM, 3420 MAIN STREET. This fine residence was built in the late 1820s and early 1830s for Capt. Daniel C. Bacon, whose portrait and abbreviated history can be found on page 4. It was later owned by his grandson Robert Bacon, who served as ambassador to France prior to his death in 1920. The building now houses condominiums. (Courtesy of the Barnstable Patriot.)

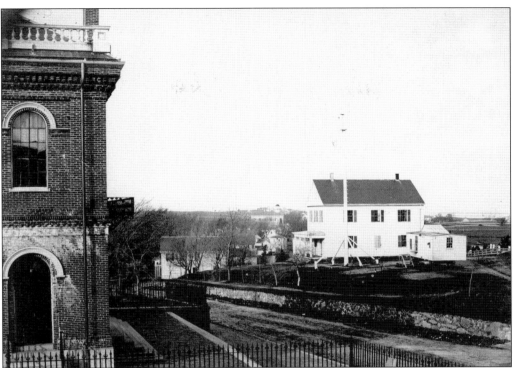

COBB'S HILL. The customs house (now the Trayser Museum) is pictured with its original balustrade and side entrance. Also shown are the schoolhouse erected in the 1850s, the front of the corner store (downhill), and the courthouse (center background). To the right of the school, one can see across open meadows and marsh to Rendezvous Lane and Barnstable Harbor. Notes on the photograph suggest a date of 1864 or 1865. (Courtesy of the Barnstable Patriot.)

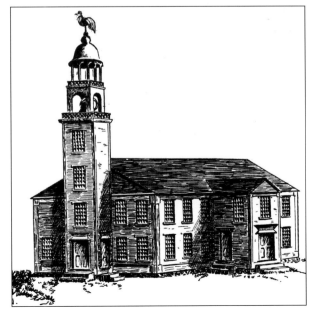

THE MEETINGHOUSE ON COBB'S HILL. The first meetinghouse for the East Parish was built soon after the division in 1717 into two parishes, on the site of the present Unitarian church on Cobb's Hill. Vaughn D. Bacon made this drawing from a sketch by Reverend Abbott, who preached the last sermon made before the building (too large for its congregation) was razed in 1853. The drawing shows the East Parish meetinghouse after the building was enlarged in 1753. The original cost of 450 pounds was defrayed by the sale of pews and by increased taxes. (Courtesy of the Barnstable Patriot.)

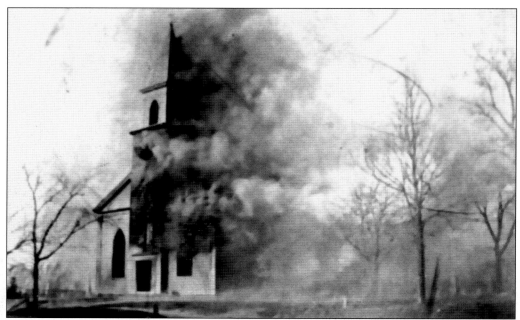

THE UNITARIAN CHURCH AND THE 1905 FIRE. The church that replaced the first East Parish meetinghouse lasted until 1905, when it was destroyed by fire. (Courtesy of the Barnstable Patriot.)

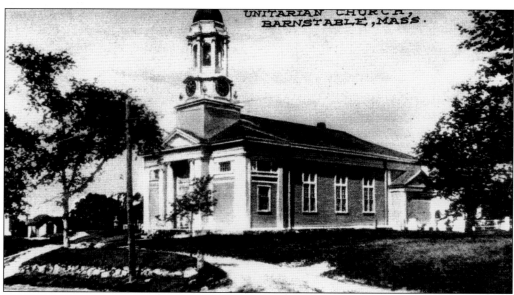

THE PRESENT UNITARIAN CHURCH. The main portion of the present Unitarian church was completed for $10,000, and the building was dedicated in 1907. The church was designed by Guy Lowell, the distinguished architect of the Boston Museum of Fine Arts. Lowell summered in Cotuit. Not shown here is the addition completed in 1960 and named Warren Hall after the church's longtime and beloved minister, Kenneth Warren. (Courtesy of Dan Knott.)

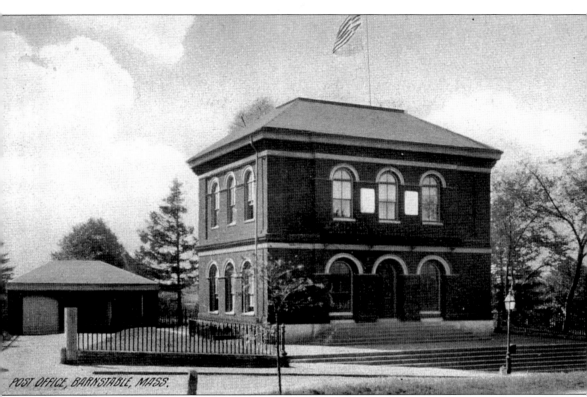

POST OFFICE, BARNSTABLE, MASS.

THE TRAYSER MUSEUM. Notwithstanding revenues less than expenses, Maj. Sylvanus B. Phinney, customs collector, persuaded Washington's power brokers that the 7th Customs District (Cape Cod except Falmouth) needed a fireproof brick customs house to conduct business and to secure documents. In 1855, Congress authorized construction of a customs house and post office in Barnstable of bricks with fireproof iron beams to cost not more than $20,000. In 1856, a second appropriation of $9,870.80 was made for the cast-iron fence, grading the grounds and completing the building. The building was designed by the first supervising architect of the U.S. Treasury, Ammi Burnham Young, using a sophisticated structural system of cast iron. The completed brick structure, occupied in late 1856, was the first fireproof building on the Cape. In 1960, the General Services Administration deeded the premises to the town to be used as a museum. Implemented by a committee formed from the town's historical societies, the museum's name honors Donald G. Trayser, a well-known local historian. Open in the summer months, the Trayser now houses several collections, the largest being that of the Barnstable Historical Society. The collections reflect the maritime and social history of the town of Barnstable and its seven villages.

HYANNIS ROAD. This early-1900s view looks south along the road to Hyannis from the intersection with the main road in Barnstable Village. The splendid elms are now gone, victims of hurricanes and Dutch elm disease.

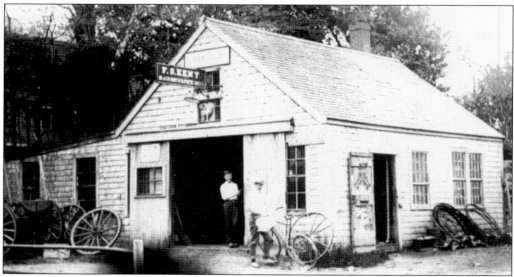

KENT'S LIVERY STABLE. This stable was located on the south side of the highway in the now open field east of 3267 Main Street.

PASSERSBY, C. 1890. This handsome couple is walking perhaps to the Phinney & Edson store. Note the parasol and the wheel rim stopped in midflight. (Courtesy of the Sturgis Library.)

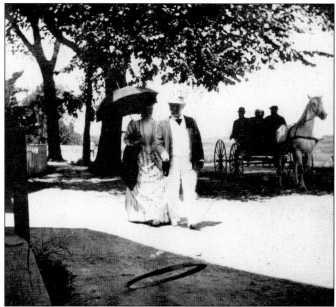

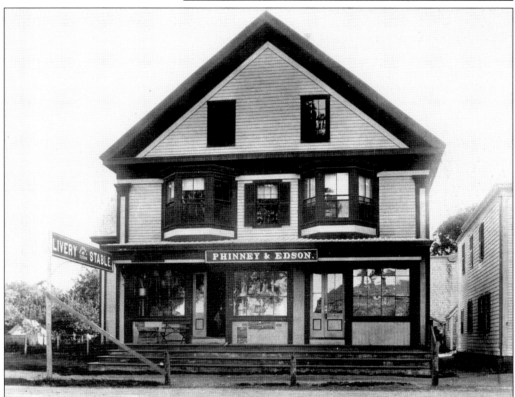

THE PHINNEY & EDSON STORE. This store stood in Barnstable Village on the south side of the King's Highway, roughly across from the present post office. The store burned in 1923. (Courtesy of the Barnstable Patriot.)

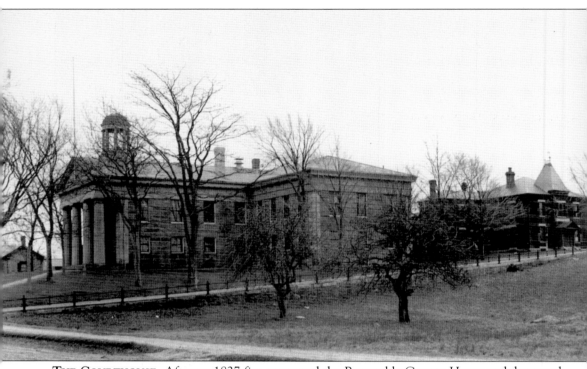

THE COURTHOUSE. After an 1827 fire consumed the Barnstable County House and destroyed extensive real estate and probate records, nationally known architect Alexander Parris was retained to design a county courthouse to replace the repository for county records and the old courthouse on Rendezvous Lane. The Greek Revival building, completed in 1832, is constructed of Quincy granite (a gray-and-black granite with few if any white flecks of feldspar) and wood simulated to look like the granite. The cornice, pediment, and the four Doric columns are wood. Here cases were heard by Lemuel Shaw and argued by many noted lawyers, including Daniel Webster. The grounds now have statues of James Otis and his sister Mercy Otis Warren, as well as a pair of cannons supposedly from the remains of Fort Ticonderoga. A plaque indicates that the cannons, with two others, were used in the War of 1812 to successfully resist a British ship from either destroying the extensive saltworks of Loring Crocker or getting the $6,000 ransom demanded for not destroying them. The picture also shows the brick jail that burned in the 1930s. (Courtesy of the Barnstable Patriot.)

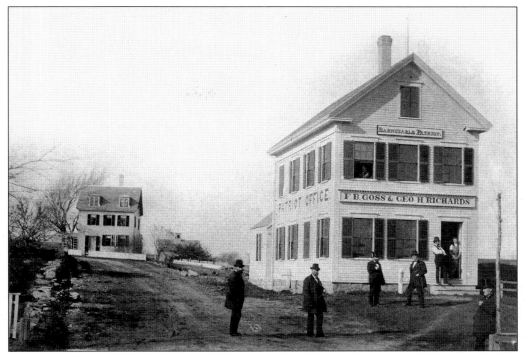

THE PATRIOT OFFICE. In 1869, F.B. Goss and George H. Richards acquired control of the *Patriot* from Sylvanus Phinney. In 1873, they constructed this building on Railroad Avenue. Goss is third from the left in this photograph, and Phinney is leaning against the post. (Courtesy of the Barnstable Patriot.)

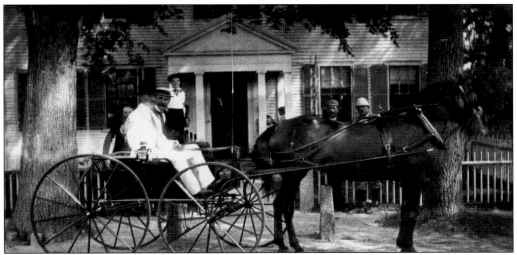

GENTLEMEN IN A CARRIAGE. This is one of a collection of salt-print photographs originally bound together with a cover that reads, "Barnstable 1888 and 1890 W.R. Bascomb." The collection was found in the Daniel Davis (1713–1799) house, west of the Sturgis Library, and has been given to the library by Mrs. Robert Barnet. Daniel Davis was, according to Trayser, "a leader in Barnstable affairs before, during and after the Revolutionary War." The coach is in front of the Globe Hotel, later the Barnstable Inn. (Courtesy of the Sturgis Library.)

THE BUILDING AT 3166 MAIN STREET, C. 1890. The Barnstable Institution for Savings, founded in 1831, built this Victorian building in 1860 next to the Globe Hotel. John Munroe, a local silversmith, was treasurer for 40 years. Other local families associated with the bank included Crockers, Hinckleys, and Scudders. Town records say that although the bank had assets of $3 million at one time, it closed after the depression of 1877. Since 1882, the building has housed offices. (Courtesy of the Sturgis Library.)

THE STURGIS LIBRARY. This, the second dwelling of Rev. John Lothrop, dates from 1644, making it possibly the oldest house in Barnstable. Later, Capt. William Sturgis was born here. He bequeathed the property and a fund to trustees to establish a library for the educational enrichment of the people of Barnstable. The original trustees—Samuel Hooper, Lemuel Shaw Jr., and Edward Hooper—opened the Sturgis Library in 1867 with 1,300 books. Today, John Lothrop's old home is said to be the oldest library building in the United States. (Courtesy of the Sturgis Library.)

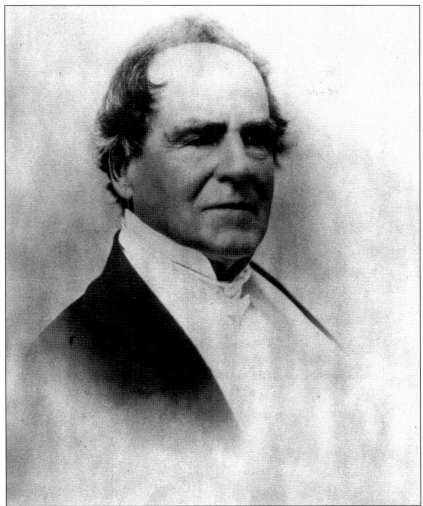

CAPT. WILLIAM STURGIS (1782–1863). Sturgis attended school until age 15, worked for a year, and learned navigation. After his father died following a pirate attack, Sturgis went to sea in the Northwest-China fur trade. He kept a detailed log (noting at one point that they had caught four albatross on baited hooks and baked them into a fine sea "pye") and learned the language of the Native Americans, with whom he was popular and dealt skillfully. By age 19, he was on his second Northwest-China voyage and was put in command of the *Caroline*. At 24, he had completed three China voyages and was the leading captain in the trade. After a fourth in the fur trade, he sailed a final trip direct to Canton on the *Atahualpa*. In the Macao Roads about 70 miles south of Canton, his ship was attacked by 16 pirate vessels. After several hours, the pirates were successfully repulsed, but they attacked again later. The attacks were led by Appotesi, a notorious pirate chief who was ultimately captured by the Chinese and, according to Henry Kittredge, put to death by the slow torture known as "the thousand cuts." Quitting the sea in 1810 at age 28, Sturgis established the firm of Bryant and Sturgis, which until 1840 had half the Pacific Coast trade under its disposition. He served in the Massachusetts legislature from 1814 until 1845 and was always sensitive to the welfare and treatment of the Native Americans. The Sturgis Library of today is a fitting tribute to the acumen, intellectual curiosity, and humanity of William Sturgis. (Courtesy of the Sturgis Library.)

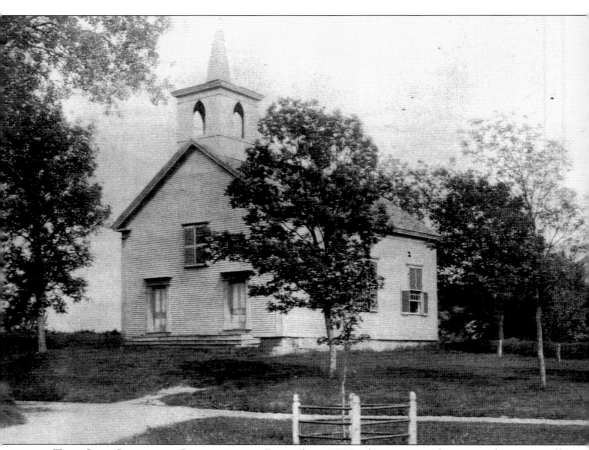

THE OLD COLONIAL COURTHOUSE. Erected in 1772, this is one of two royal courts still standing in Massachusetts; the other is in Plymouth and dates from 1749. The building seated the King's Court until 1774, when James Otis Jr., Samuel Adams, and about 1,500 patriots gathered to protest the Crown's Writs of Attainder, which deprived colonists of the right of trial by a jury they selected. Abandoned by the king's judge after the protest, it became a Commonwealth Court after the Revolution and remained such until 1838, when the present courthouse was built in the village. It was used briefly for fish storage and was then purchased by the Third Baptist Church for a meetinghouse. The Baptists turned the building to face Rendezvous Lane, added the colored-glass windows, and attached the wing that faces Main Street. After over 100 years as a church, the building was acquired by Tales of Cape Cod, an organization founded in 1949 as a Cape-wide historical group dedicated to preserving and disseminating the history of the peninsula. The building is now used each summer for lectures of historical interest. The triangular area in front of the courthouse, once much larger, was used as a militia training ground in Colonial times. Soldiers left from there to go to war in 1775 and during the War of 1812. (Courtesy of David Crocker.)

THE ALLYN HOUSE, 2730 MAIN STREET. Legend has it that this house, built in the late 1600s and recently moved back from the street, was haunted by a black cat because Lydis Towerhill deemed herself ill treated by the Allyn family. So, she complained to her mother, Liza, a witch. The cat, Liza's familiar, it was said, did varied mischief, including turning milk sour, throwing pots and pans, and breaking furniture. (Courtesy of Donald Griffin.)

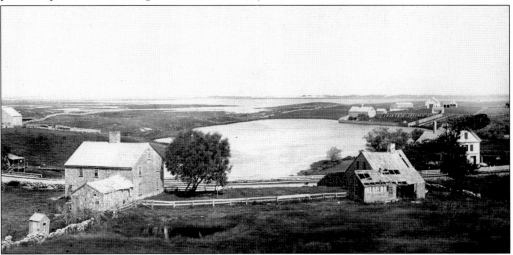

POND VILLAGE, C. 1900. This view of Coggins Pond shows the icehouse (left) and the Stephen Smith estate (across the pond), with the Paine homestead in the foreground. Nearby stood the home of firstcomer Thomas Hinckley, the last governor of the Plymouth Colony until its union with the Massachusetts Bay Colony in 1692. The second meetinghouse, which served until the division into two parishes in 1717, was also located near the pond. (Courtesy of the Sturgis Library.)

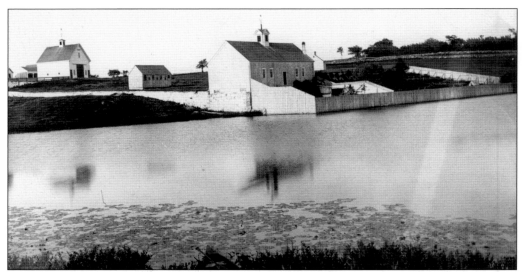

THE SMITH FARM. Stephen Smith (1805–1875), born near Coggins Pond, lost his mother in 1811 and had an unhappy childhood. He studied cabinetmaking in Sandwich, opened shop in Boston in 1828, and *c.* 1832 invented his prizewinning roll-top desk, which became widely popular by 1840. In the 1850s, he purchased extensive land abutting Coggins Pond and had his scientifically planned farm built there. According to a funeral testimonial, he had "a generous and large hearted nature [and] never forgot the struggle of his early days." (Courtesy of the Sturgis Library.)

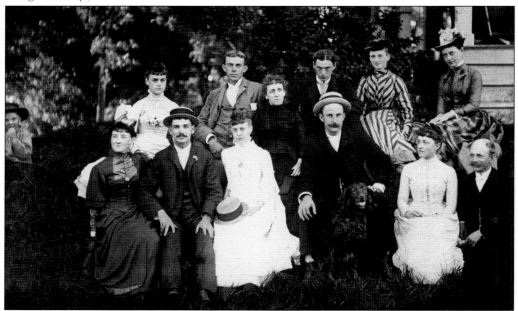

A GROUP PORTRAIT, C. 1890. This portrait includes William V. Tripp (back row, fourth from the left); Tripp's future bride, Emily Beale (back row, fifth from the left); Mary Beale, later Mary Hutchins (front row, far left); Elizabeth Chadwick Day (front row, fifth from the left); and Day's future husband, Joseph H. Beale (front row, far right). The others are unidentified. (Courtesy of the Sturgis Library.)

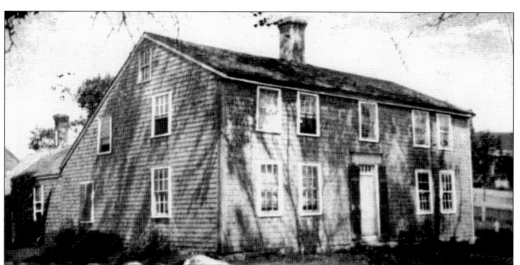

The Oldest House? Known as Grey Shingles, this saltbox at 2390 Main Street was long thought to be the oldest dwelling in Barnstable. After its purchase by the town in 1964, expert architects concluded that, while it sat on an older foundation, it was in fact constructed *c.* 1740. Subsequently sold, Grey Shingles is now a single-family residence. For many years, however, it was a two-family house. In 1870, the eastern half was purchased by Capt. Rueben C. Seabury in time for the wedding of his daughter, L. Addie Seabury, to William R. Sturgis on February 2, 1875. (Courtesy of Mr. and Mrs. John Ehret.)

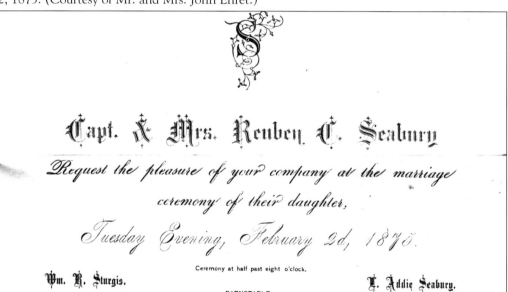

Capt. & Mrs. Reuben C. Seabury

Request the pleasure of your company at the marriage

ceremony of their daughter,

Tuesday Evening, February 2d, 1875.

Ceremony at half past eight o'clock.

Wm. R. Sturgis. L. Addie Seabury.

BARNSTABLE

The Wedding Invitation. Capt. Rueben Seabury, born in 1830 and father of the bride, had served as master of a packet plying between Boston and New York until the advent of steam when he retired to Barnstable to farm. The wedding was held at Grey Shingles. The *Patriot* of the wedding day said it was "good weather for sleigh-riding" and added that there was ice 14 inches thick at "Cotuit Port." William Sturgis, the groom, worked in various jobs—at a restaurant, with the *Patriot,* and at the customs house. He died in 1906 at age 54 and was survived by Addie and their two sons, Edward and Howard.

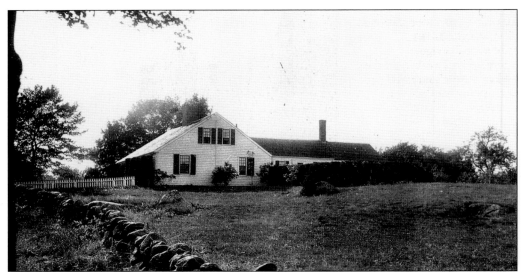

THE CROCKER HOMESTEAD, 2110 MAIN STREET. According to town records, this well-proportioned full Cape was built *c.* 1726 by William Crocker Jr., the grandson of John Crocker, a first settler of Barnstable who was given a large tract of land in 1639 and died in 1669. The house is owned today by a descendant of William Crocker Jr. (Courtesy of Marjorie Handy.)

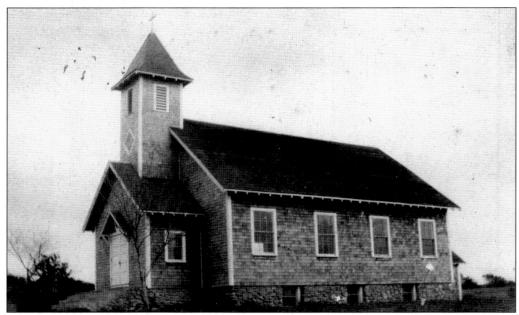

THE FIRST LUTHERAN CHURCH, 1663 MAIN STREET. The congregation was established in 1915 by Finnish residents of West Barnstable, and the church was built nine years later. Finnish immigrants were attracted to West Barnstable because of work opportunities at the brickyard, with cranberries, and in farming, fishing, and construction. The 21 charter members included five Wirtanens; two Syrjalas, Hakkarainens, Makis, Aittaniemis, and Michelsons; and one from each of the following families: Lunderquist, Lampi, Heinonen, Parvijainen, Ahola, and Lahteinen. (Courtesy of the Whelden Library.)

OUR LADY OF HOPE CHAPEL, 1581 MAIN STREET. Immigrant Portuguese fisherman and workers in the brickyard were said to be the impetus for this Catholic church, with its striking anchor symbol. It was constructed in 1914 largely by parishioners with local brick contributed by the West Barnstable Brick Company. The architect was Matthew Sullivan, and the building is said to be a copy of a small chapel on the Basque seacoast. Emilio R. Silva, foreman at the brickyard, supervised construction and insisted that only local brick be used. (Courtesy of the Barnstable Patriot.)

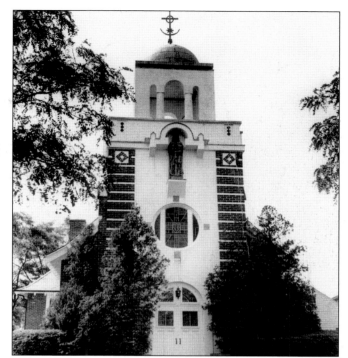

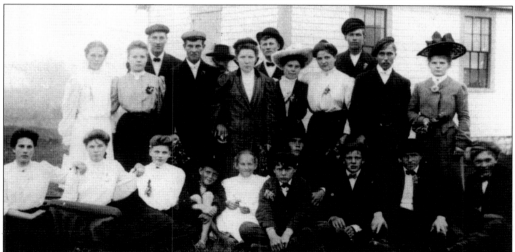

TEMPERANCE HALL. Built in 1906, this was an important meeting place on Plum Street for West Barnstable's immigrant Finnish population. Martin Wirtanen recalls that morning Sunday school was held there in Finnish, but because English was deemed important, children were required by their parents to go to afternoon Sunday school at the West Parish Church, where the lessons were in English. From left to right are the following: (front row) Finna Pirttine, Mary Maki, Helma Manni, unidentified, Oldest Pyy, unidentified, Elmer Wirtanen, unidentified, Axel Hakkarainen, and Olmi Siltanen; (middle row) ? Michelson, ? Aittaniemi, Henry Aittaniemi, Rose Wiinikainen, Salmi Ruska, unidentified, Emil Heinonen, and Anna Lampi; (back row) Jonas Niskala, John Davidson, Aino Oinonen, and Tidie Benttinen. (Courtesy of the Whelden Library.)

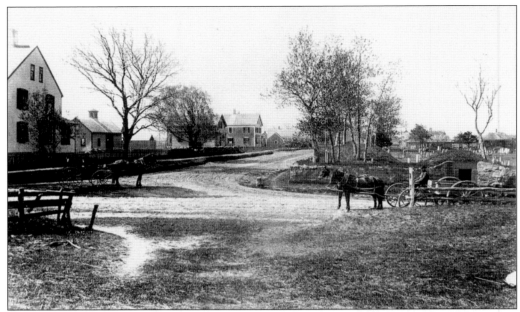

MEETINGHOUSE WAY. This view looks south along Meetinghouse Way from the intersection with the Old King's Highway. In that direction are the Village Store, the railroad depot, the Whelden Library, the Enoch Pratt House, and the West Parish Church. (Courtesy of the Sturgis Library.)

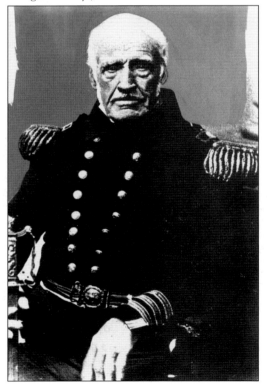

CAPT. JOHN PERCIVAL (1779–1862). Born in West Barnstable, John Percival was one of the town's most illustrious citizens. As did many other Cape Codders of his era, he went to sea early. He was impressed by the British navy and served with distinction in the U.S. Navy during the War of 1812, earning the nickname "Mad Jack." Percival commanded the *Constitution* throughout the vessel's 52,279-mile voyage around the world in 1844–1846. He is buried in West Barnstable. For more information, see *Mad Jack Percival*, by West Barnstable author James H. Ellis. This photograph dates from 1860. (Courtesy of James H. Ellis.)

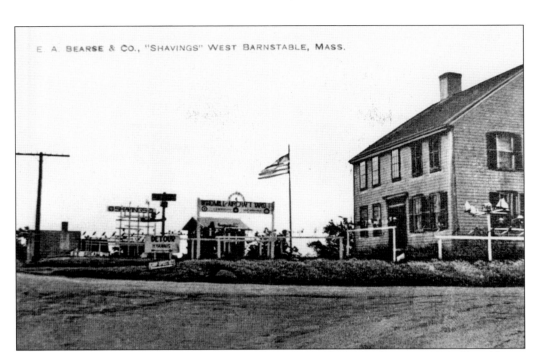

E. A. BEARSE & CO., "SHAVINGS" WEST BARNSTABLE, MASS.

THE PRINCE JENKINS HOUSE. Prince Jenkins, a carpenter, built this house *c.* 1808. He sold it in 1814 and moved to Ohio. More than 100 years later, it was a source for windmill weather vanes and other whirl-a-gigs, the only one authorized to use *Shavings,* the name of Joseph Lincoln's novel about a whirl-a-gig maker. The brightly painted devices were a common item for sale to summer tourists to capture their free dollars for Cape Cod. (Courtesy of the Whelden Library.)

THE OLD VILLAGE STORE. Built on Lombard Trust land, this store was bought by Abel D. Makepeace in 1904 from Melvin Parker so credit could be offered to Makepeace cranberry and brickyard employees. (Courtesy of the Whelden Library.)

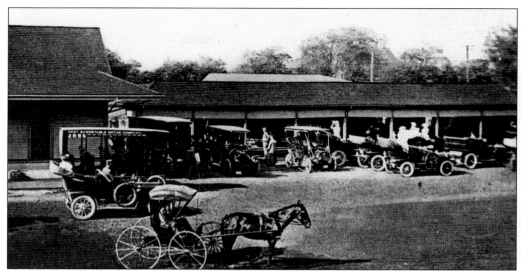

THE WEST BARNSTABLE RAILROAD DEPOT, C. 1910. The railroad was extended to West Barnstable in 1854. The original depot (shown here) burned. Horse-drawn coaches transported train passengers to Cotuit, Osterville, and points south, and there were sometimes delays. Legend has it that this part of West Barnstable is known as "Shark City" because there were card players at the station ready to relieve delayed passengers of their boredom and money. (Courtesy of the Whelden Library.)

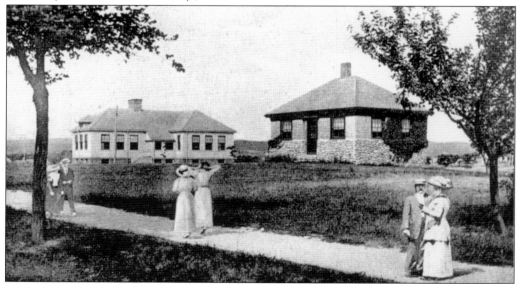

THE WHELDEN MEMORIAL LIBRARY, 2401 MEETINGHOUSE WAY. The library began with several hundred volumes given by Mrs. George Linder. At one point, the books were kept in a room in New Otis Hall. In 1905, John Bursley, Howard Parker, and Harry Jenkins obtained permission to build a separate library on Lombard Trust land. This was accomplished almost entirely with volunteer labor under the direction of Zebina H. Jenkins. In the early 1920s, Asenath Whelden died and bequeathed $8,000 to the library, which was enlarged and given its present name. The photograph shows the elementary school on the left. (Courtesy of the Whelden Library.)

THE LOMBARD HOUSE. In 1754, Parker Lombard died, bequeathing 50 acres to the town to "be hired out to the highest bidder . . . and the Rent or Income of it . . . for the use and benefit of the Poor of the Town . . . from one generation to another forever never to be sold." In 1769, the town constructed on the property what became known as "the Poorhouse," which was eventually expanded from the original 26-foot square building. After nearly 200 years, the old building (shown here) was razed in 1972. Rentals from other structures on the Lombard property, including the depot, the New Otis Hall, and the Village Store, still benefit the poor. (Courtesy of the Whelden Library.)

THE OLD SELECTMAN'S OFFICE, c. 1970. This Victorian structure was built in 1889, when the town's population was still centered on the north side. It was one of the first Barnstable buildings constructed solely for municipal purposes. Town use stopped by 1978, and the building deteriorated. In 1989, it was restored through efforts of the community and the Barnstable Historical Society. Labor and materials were contributed by Matt Dacey and his father, William E. Dacey Jr. Today, it is used during warm weather to display the works of local artists, with shows changing on a frequent basis. (Courtesy of the Whelden Library.)

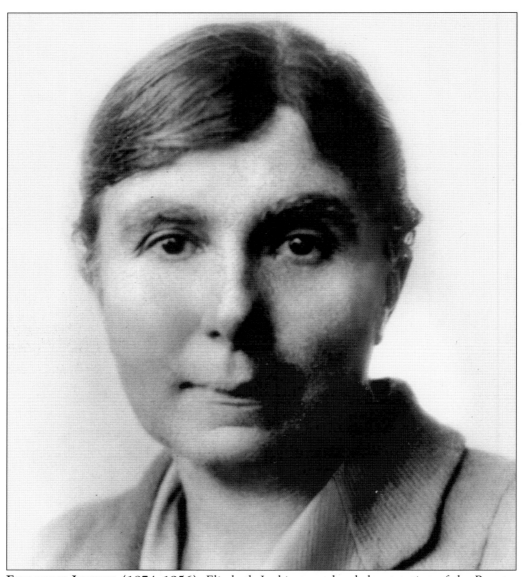

ELIZABETH JENKINS (1874–1956). Elizabeth Jenkins spearheaded restoration of the Rooster Church. Born in West Barnstable, she was the daughter of deepwater sea captain James Hamblin Jenkins and his seagoing wife, Ruth. She went to high school in Hyannis and, after interruptions, graduated at 30 from Radcliffe College, Phi Beta Kappa, in 1905. Her graduate work included a year at Oxford. She had joined the West Parish Church at age 15 and showed singular dedication to its well being. In 1929, she started a fund for restoration of the deteriorating meetinghouse and worked steadily to grow that fund for years thereafter. Stimulated by her efforts, generosity, and enthusiasm, the project gathered steam, and the establishment of the West Parish Memorial Foundation broadened community support. The restoration was completed in 1958, two years after her death. The foundation adopted a resolution that noted, "She labored single-handed for years when there were no others to help; by her own devotion she inspired others to see the vision that was so real to her." (Courtesy of the West Parish Church.)

THE WEST PARISH COCK. The gilded cock weather vane was imported from England in 1723. From bill to tail, it measures five feet five inches. For over 275 years, it has adorned the West Parish meetinghouse, often called the Rooster Church. Since 1958, the restored meetinghouse has stimulated for many a sense of history and pleasure, all through the efforts of Elizabeth Jenkins and those who helped realize her dream. (Courtesy of the Barnstable Patriot.)

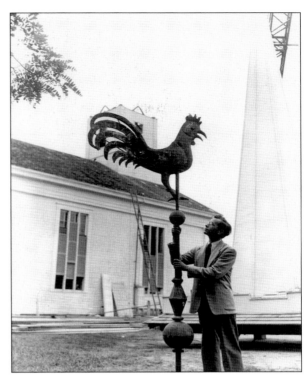

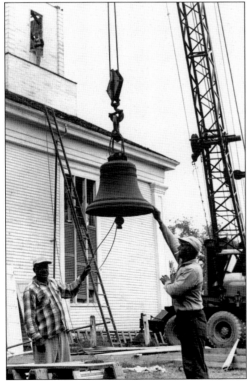

LOWERING THE BELL. This 922-pound bell, cast by Paul Revere, was given to the West Parish in 1806 in memory of Col. James Otis, father of patriot James Otis Jr., Mercy Otis Warren, and Samuel Allyn Otis. Samuel, the first secretary of the U.S. Senate, held the Bible on which George Washington took the oath of office. Today, the bell still tolls its message from the steeple of the restored church. (Courtesy of the Barnstable Patriot.)

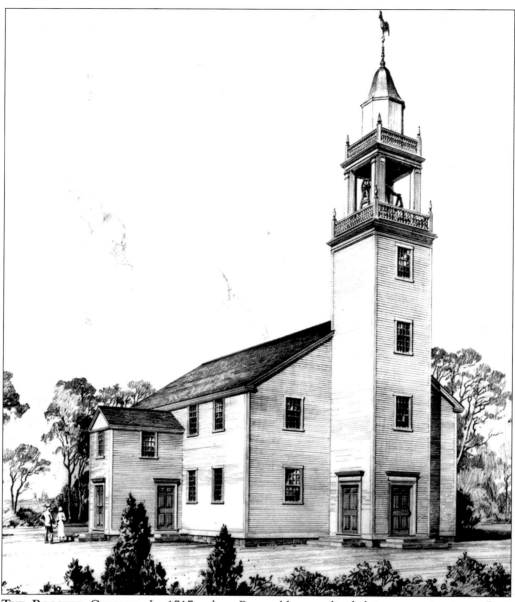

THE ROOSTER CHURCH. In 1717, when Barnstable was divided into two precincts, Rev. Jonathan Russell decided to move his congregation to the West Parish. Construction of the meetinghouse began in 1717. Time took its toll, and in 1929, Elizabeth Jenkins, Edwin B. Goodell Jr. (an architect), and Forest Brown (a builder) undertook their 30-year commitment to its preservation. Through the efforts of Elizabeth Jenkins, others recognized that the building had great historic interest. A group of prominent citizens—including Dr. Edgar Park (president of Wheaton College), Charles L. Ayling, Henry C. Kittredge, Donald G. Trayser, and others—formed the West Parish Memorial Foundation "to preserve the West Parish Meeting House . . . as an historic memorial of early America and Americans." Completed in 1958, the restored building is said to be the oldest Congregational church in America. Both inside and out, it is an outstanding gem of historic preservation. (Courtesy of the West Parish Church.)

Two

SANDY NECK

Long, lofty, wild and fantastical beach, thrown into a thousand
grotesque forms by the united force of wind and waves. . . .

—Timothy Dwight, president of Yale, in an 1800 letter

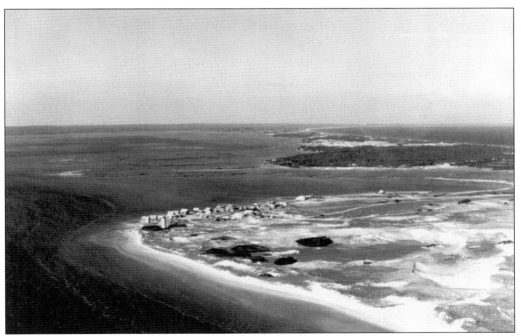

SANDY NECK. Sandy Neck is the jewel in Barnstable's crown. Its barrier beach and migrating dunes extend six miles eastward from Sandwich, protecting Barnstable Harbor and almost 6,000 acres of salt marsh. Arrowheads and shell middens with ancient oyster shells appear and disappear in the shifting sands, bearing witness to the more than 2,000 summers during which the area was occupied by Iyanough and his Wampanoag ancestors. In early Colonial days, the Great Marsh furnished grazing and salt hay for the settlers' livestock. Whale blubber was boiled down for oil on the marsh to the south of the Neck. Later, Braley Jenkins took his crews of women into the dunes to harvest the wild cranberries. For generations, the marsh has yielded clams and wildfowl, and the harbor has been a generous source of fish, mussels, and oysters. Owned mostly by the town, the Neck is still a pristine wilderness with a small cottage colony at its east end and a scattering of gunning camps along its south side.

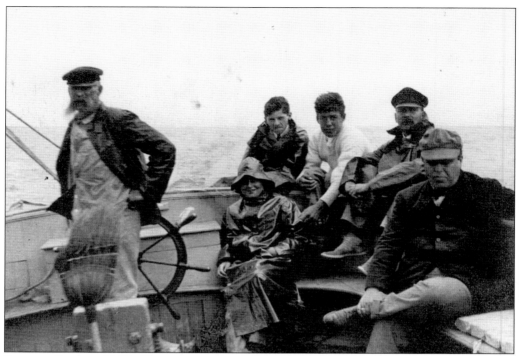

SAILING OUT, C. 1905. There is enough wind to drive this big cat to please its passengers and to keep the skipper's mustaches afloat in the breeze. We will join them at Scudder Lane. Before sailing to Sandy Neck, we will detour west by Harbor Heights, also known as Calves Pasture Point.

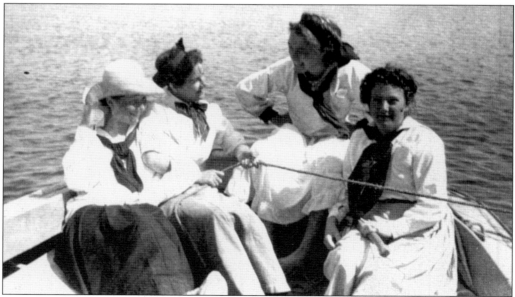

FOUR LADIES AT SEA, C. 1910. These four are sailing out to visit the Kittredge-Bowles duck shanty on Sandy Neck. They are, from left to right, Kitty Bowles, Frances Kittredge, Patsy Livingston, and Dora Kittredge. (Courtesy of Frances Bush-Brown.)

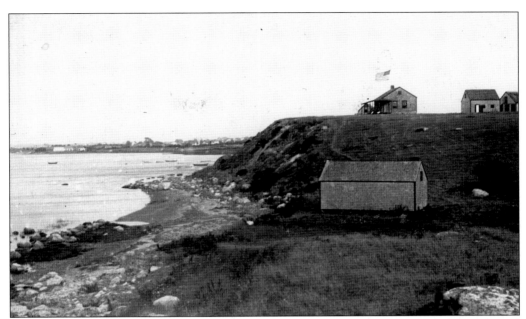

HARBOR HEIGHTS, C. 1900. In the 1890s, these summer cottages were built by Nathaniel Percival and Maj. Frank Briggs on what had been common lands. As livestock became less common, a second growth of shrubs and trees moved in, and the area is now heavily vegetated. (Courtesy of the Barnstable Patriot.)

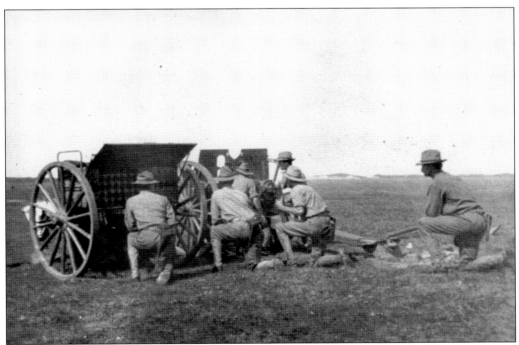

TROOP TRAINING, C. 1915. At the time of World War I, National Guard troops trained at the marsh edge to the west of Navigation Road in West Barnstable. (Courtesy of the Whelden Library.)

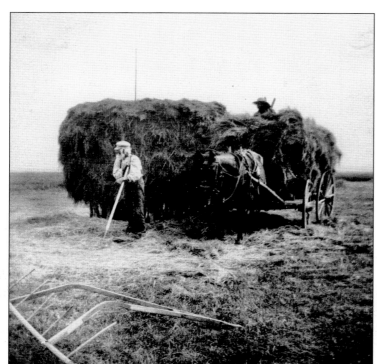

SALT HAY. Hay was one asset that brought firstcomers to Barnstable in numbers sufficient to warrant incorporation of the town in 1639. It was used for packing bricks, for insulating houses and icehouses, and for feeding and bedding horses, cows, sheep, and pigs. The harvests took place in August, when tides were at the lowest and the marsh was solid enough to support the horses, which were sometimes fitted with large, round bog shoes. (Courtesy of Frances Bush-Brown.)

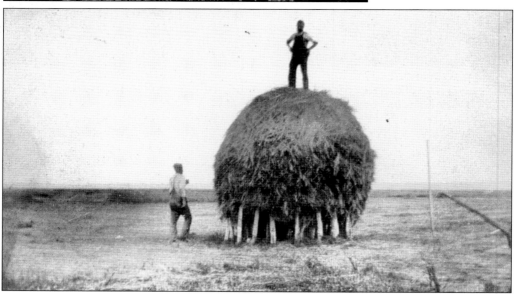

THE STADDLE, C. 1900. Cut hay was transferred to a staddle, a 15-foot circle of pilings sunk into the marsh to act as a platform that could hold up to two tons. This enabled the harvest to continue while tide and other conditions were at the optimum. At one point, there were said to be 1,000 staddles in the Great Marsh. With the coming of the railroad, tourism, and development of more productive middle-western farms, general farming in Barnstable tailed off, and ice blocks in the Portland Storm of 1898 took out most of the staddles, which were never replaced. (Courtesy of Frances Bush-Brown.)

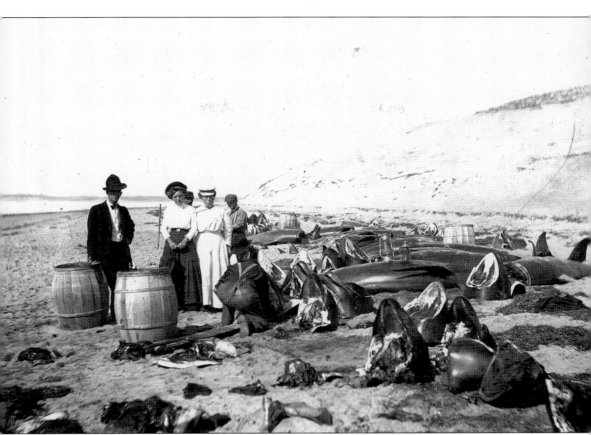

INSHORE WHALING. In 1715, the Neck was apportioned for private ownership, "Reserving Priviledge & Use of fouyr spots . . . for . . . try houses . . . for ye laying blubber barrels, wood, & other nessesceries for ye trying of oyl." Access was also reserved from the "back beach" to the try yards on the marsh. In 1794, Rev. John Mellen wrote, "Seventy or Eighty years ago the whale bay fishery was carried on in boats from shore, to great advantage. The business employed nearly 200 men for three months of the year, the fall, and the beginning of winter." Whale houses on the back beach were large, permanent structures. Right whales, which floated, were the favored prey. After they vanished, pilot whales and porpoises may have been harvested for head oil. This picture from Wellfleet could have been from earlier days on Sandy Neck. (Courtesy of the Sturgis Library.)

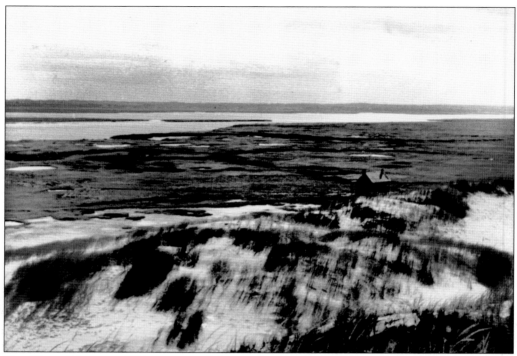

TRY YARD MEADOW. This portion of the marsh is known as Try Yard Meadow, where in the late 1600s and early 1700s, whale blubber brought by horse-drawn wagon from the "back beach" was boiled down for oil. The gunning camp, now on the National Register of Historic Places, was built in the early 1900s for duck shooters. After years of infrequent use, a thorough cleaning turned up a set of dress tails. One story says that they belonged to a Russian counsel who, after duck shooting and perhaps a drink or two, left his tails behind him. (Courtesy of James Calvin.)

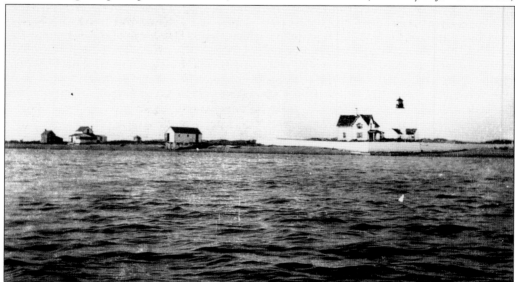

THE COTTAGE COLONY, C. 1890. Settlement at the Point was sparse. (Courtesy of the Sturgis Library.)

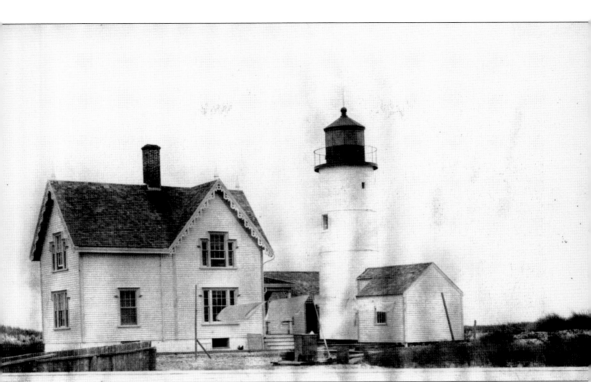

THE SANDY NECK LIGHT, C. 1890. In 1826, the federal government purchased land for the light at Sandy Neck. In 1857, the 45-foot brick light tower (the present landmark) was erected on ground 33 feet above mean high water to replace an earlier light. The keeper's house was built in the 1880s. Because of changes in the configuration of Sandy Neck, the light was moved to a steel structure in 1931. In 1934, the old light was decommissioned and its lamp, reflectors, and glass slides were removed. Shortly thereafter, the tower and lighthouse were sold and have since remained in private ownership. During World War II, the keeper's house was used by the Coast Guard in conjunction with training exercises. (Courtesy of the Sturgis Library.)

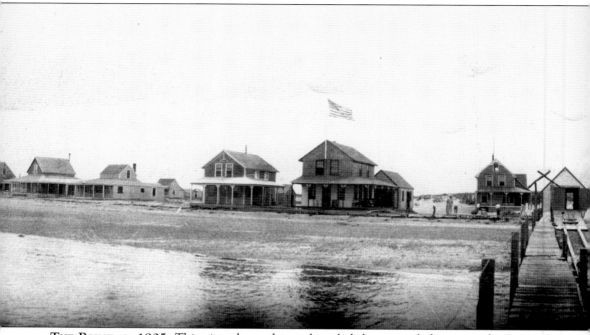

THE POINT, C. 1905. This view shows the working lighthouse, early houses at the Point, the Barnstable Harbor House, and the former lighthouse pier and boathouse. The usual access to the cottage colony would have been by dory, designed to be seaworthy and to row easily. Next to the keeper's house on the beach is the flag-flying building once known as the Barnstable Harbor House (today, the Chowder House). In the late 1880s and 1890s, the restaurant could

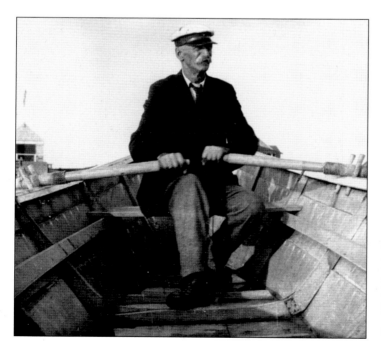

THE ASSISTANT CHEF. Herbert Lovell helped his father run the Barnstable Harbor House. The picture dates from the 1890s. (Courtesy of Dr. Tony Lovell.)

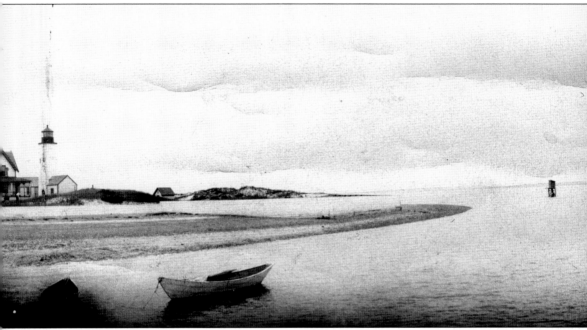

seat 25 diners and was run by Benjamin Lovell and his son Herbert. The handbill for the restaurant reads, "Barnstable Harbor House, clam chowder, clambakes, and lobster furnished for parties at short notice. Fruit, confections, peanuts & etc. constantly on hand and for sale cheap. Ginger ale, birch, lemon and vanilla soda—Cigars and tobacco. Seafowl shooting months of October & November."

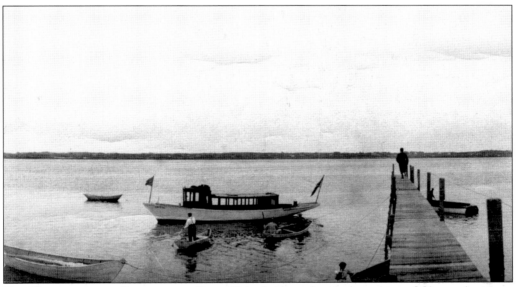

THE VIEW FROM THE LIGHTHOUSE PIER. This photograph, taken on the same day as the image above, looks south to Barnstable along the lighthouse pier.

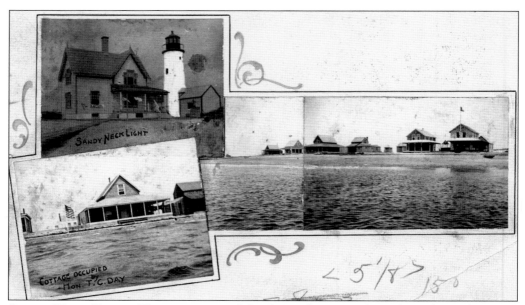

SANDY NECK VIEWS. This composite of Sandy Neck images dates from the early 1900s. (Courtesy of the Barnstable Patriot.)

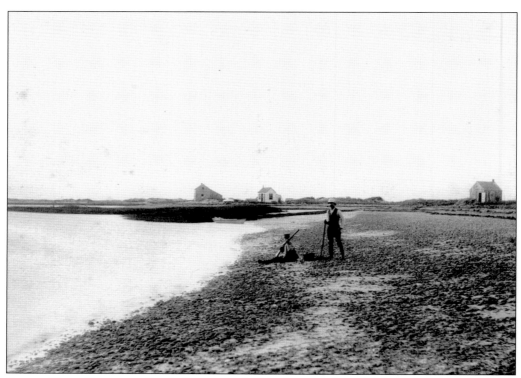

SANDY NECK GUNNERS. Frank Sprague took this photograph in 1895.

MRS. LOVELL'S CAMP. In the late 1920s, Constance Prowse Lovell started the Sandy Neck Camp to afford children a summer at the shore. The 1929 prospectus noted, "Sandy Neck is a beautiful clean sandy stretch of land, dotted with sand dunes, low grasses and patches of pine woods, away from the dangers that lurk on the mainland, where automobile traffic is a constant menace to life and limb." The prospectus shown here is from 1927–1928. (Courtesy of Jack Hill.)

Sandy Neck Camp

For Children, Ages 6-12

Owned and operated by

CONSTANCE PROWSE LOVELL, R. N.

Barnstable Village

CAPE COD, MASSACHUSETTS

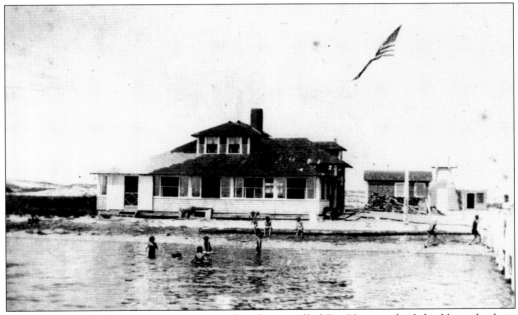

THE BIG HOUSE. Camp activities centered at the so-called Big House, which had been built in 1915 by Shirley Lovell and master carpenter W. Davis Holmes. Shirley and his brother, H. Leston Lovell, both maintained winterized houses on the Neck. The only other year-round residents were the lighthouse keeper and his family. The Big House is shown with its pier c. 1930. (Courtesy of Jack Hill.)

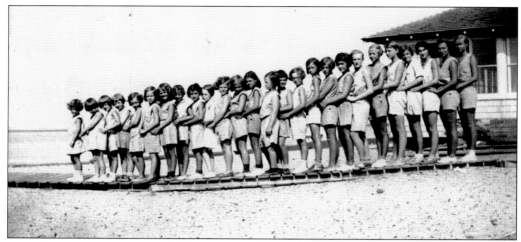

CAMPERS. Posed in front of the Big House is a group from 1930. The camp flourished until, at its peak, there were 155 children, 25 counselors, and various helpers. The last year of camp operations was 1957. (Courtesy of Jack Hill.)

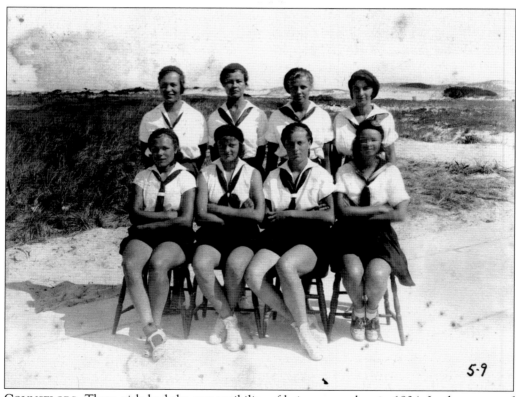

COUNSELORS. These girls had the responsibility of being counselors in 1934. In the center of the front row, Geraldine is on the left and Marjorie is on the right. They were the daughters of Shirley and Constance Lovell. Marjorie, a lieutenant nurse in World War II, was killed in a plane crash in Rome close to the end of the war. (Courtesy of Jack Hill.)

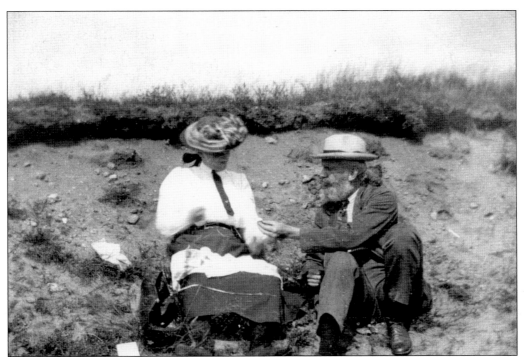

HUNTING ARROWHEADS, C. 1900. For generations, Sandy Neck has meant to many a place to rest, relax, and pursue one's interests. In this view, Professor Kittredge and a companion search for Native American artifacts at an unidentified location. Kittredge found many pieces on Sandy Neck, and portions of his collection are at the Trayser Museum. (Courtesy of Frances Bush-Brown.)

A DUNE PARTY, C. 1910. Most in sparkling white, this group is enjoying the sun and dune-top views of the marsh, the harbor, and Cape Cod Bay. (Courtesy of Frances Bush-Brown.)

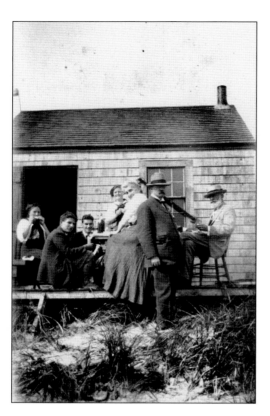

A Gunning Camp Picnic, c. 1910.
Professor Kittredge and friends are picnicking at the Kittredge-Bowles duck camp. A companion picture shows that they used one or more horse-drawn wagons to traverse the several miles out the Neck to the camp. (Courtesy of Frances Bush-Brown.)

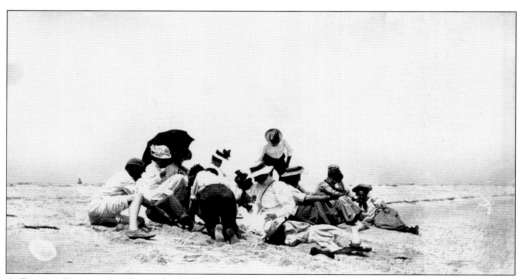

A Beach Party. In the early 1920s, people loved a Sandy Neck picnic just as they do now. (Courtesy of James Calvin.)

JOHN D.W. BODFISH (1878–1956). After graduation from Hyannis Normal School in 1899, Bodfish became principal of the Osterville Grammar School. In 1901, he lost his sight and his job. He married, worked with the blind, and in 1911, enrolled in Boston University School of Law. After graduation, he returned to Barnstable, became town counsel, and was an active participant in local politics. He was always concerned with children and Sandy Neck. He wrote poetry and a brief autobiography. In 1920, he deeded two acres of beachfront and a right-of-way in memory of his father "to see that all had public access to Sandy Neck and Cape Cod Bay." His gift encouraged the town in later years to acquire most of Sandy Neck. All who cherish Sandy Neck owe Bodfish a debt of gratitude. (Courtesy of the Barnstable Patriot.)

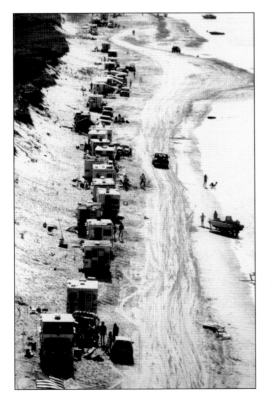

CAMPERS. As this picture of mobile homes and pleasure seekers on Sandy Neck shows, there are problems in paradise. What balance will be struck between continuing wildness and the appetite of more and more people for wildness? The photograph was taken by Cary Wolinsky. (Courtesy of the Massachusetts Audubon Society.)

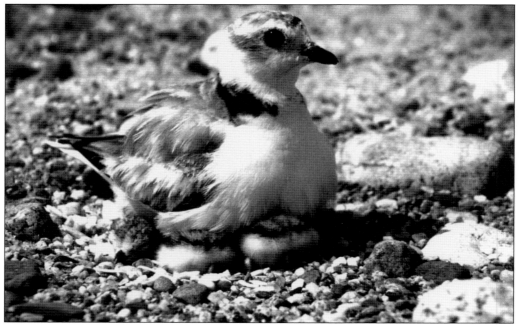

ALLIES. Diamond-backed terrapin and the piping plover are listed as endangered by the U.S. Fish and Wildlife Service under the Endangered Species Act of 1973. Protection efforts for these species, conservationists, concerned organizations, and government bodies have all helped to preserve Sandy Neck from overuse. This photograph was taken by Margo Zdravkovic. (Courtesy of the Massachusetts Audubon Society.)

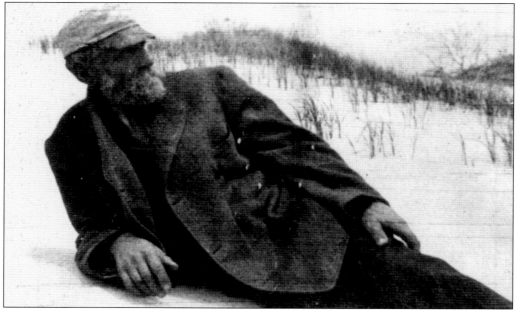

"THE FIRST BEACHCOMBER." So Martin Wirtanen, a local historian, titles this fine photograph taken in the early 1900s. Many people since have enjoyed a catnap on the dunes. (Courtesy of the Whelden Library.)

Three
NOTABLE PEOPLE
AND PLACES

I will arise and go now, to go to Innisfree,
and a small cabin build there.

—William Butler Yeats, "The Lake Isle of Innisfree"

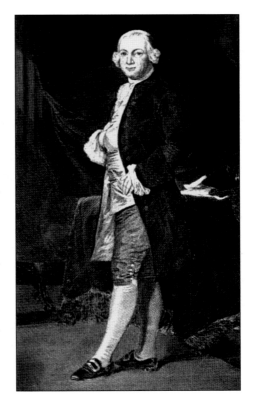

JAMES OTIS JR. (1725–1783), "THE PATRIOT."
Born into a prominent family, James Otis Jr. was
the oldest of 13 children and became Cape Cod's
most distinguished historical figure. After seven
years and two degrees (a bachelor's and a
master's), he left Harvard to read law. By 1760,
he had developed a thriving legal practice and
had been appointed advocate general. From that
position, he resigned to fight, on behalf of Boston
and Salem merchants, the abhorred Writs of
Assistance, unprecedented blank-check search
warrants authorized by the Crown to harass New
England trade. While there is no extant copy of
his famous 1761 Writs of Assistance speech, John
Adams later wrote, "Otis was a flame of fire;
with a . . . rapid torrent of impetuous eloquence,
he hurried away all before him—American
Independence was then and there born. . . ."
Beaten by a cane in a 1769 assault, Otis gradually
lost his reason and withdrew from the public
stage. In 1783, he was killed in Andover by a
stroke of lightning. (Courtesy of Cape Cod
Community College.)

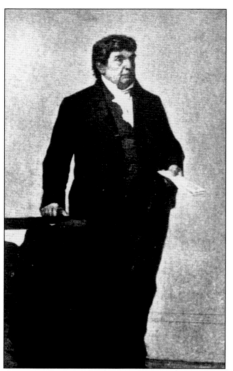

LEMUEL SHAW (1781–1861). Judge Shaw was chief justice of the state supreme court from 1830 to 1860. The period was one of great commercial expansion, requiring Shaw to deal with many novel issues and cases of first impression. A plaque in his honor at 410 Church Street reads, "Birthplace of Lemuel Shaw, Famous Jurist, whose fame extended nation wide. It has been said that no other state judge has so deeply influenced commercial and constitutional law throughout the nation." (Courtesy of Cape Cod Community College.)

THE HOUSE AT 410 CHURCH STREET. Built probably before 1683, this was the birthplace of Lemuel Shaw. His father, Oakes Shaw, was minister of the West Parish for 47 years, and so the house is known as "the Old Parsonage." Elizabeth Jenkins bought and restored it in 1914. (Courtesy of the Whelden Library.)

THE REV. ENOCH PRATT HOUSE. Rev. Oakes Shaw died in 1807. His successor, Rev. Enoch Pratt, was called the next year and served the church until 1835. In 1808, he had this splendid Federal house constructed at 2400 Meetinghouse Way with its exposed brick end, hip roof, double chimneys, and elegant architectural details.

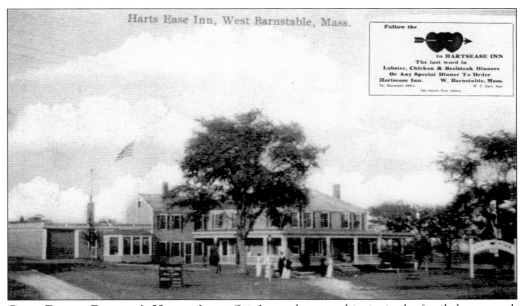

CAPT. DANIEL BURSLEY'S HOUSE. James Otis Jr. was born on this site in the family homestead, which burned in 1830. The Bursley house pictured here later became the Harts Ease Inn and home of Captain Bursley's stage line. It burned in 1941. (Courtesy of Betty Nilsson.)

THE REDFIELDS, C. 1911. In 1905, Robert Redfield was a charter member of the Barnstable Pier Association and was also a fine photographer. Many of his pictures are used in this collection. Others given to Princeton University may include some Barnstable scenes. (Courtesy of Donald Griffin.)

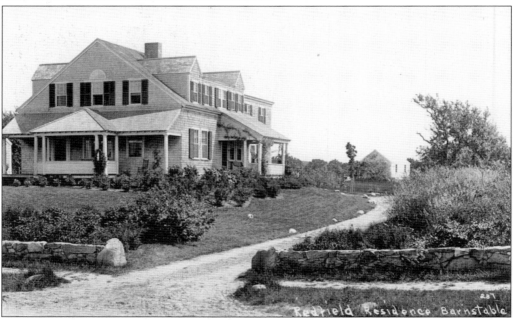

THE REDFIELD HOUSE. Originally a Methodist church located next to the Sandy Street Cemetery in West Barnstable, this building was moved in 1857 to a site next to the Lothrop Hill Cemetery. When the Methodist Society disbanded in the 1890s, the church was converted to a private residence by Robert Redfield

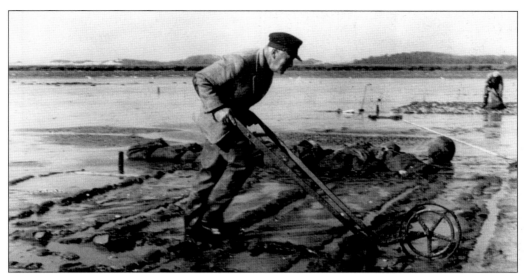

ALFRED CLARENCE REDFIELD (1890–1983). Redfield, who spent his summers in Barnstable, graduated and earned his doctorate from Harvard in 1913 and 1917, respectively. In 1921, he joined the Harvard faculty, chairing the biology department from 1934 to 1938. Long associated with the Woods Hole Oceanographic Institution, he moved to the Cape in 1942 and became the organization's associate director. Redfield Auditorium is named in his honor, and Woods Hole published the last of his books, *The Tides and Waters of New England and New York*. His later studies concerned salt marshes, including the Great Marsh in Barnstable. Here, probably in the 1960s, he is working on a clam experiment in the harbor. (Courtesy of the Woods Hole Oceanographic Institution.)

DONALD REDFIELD GRIFFIN (1915–2003). Griffin is another renowned teacher who has cherished Barnstable since childhood. He graduated from Harvard in 1938, became a professor there in 1953 and later at Cornell and Rockefeller Universities. Some of his books are *Listening in the Dark* (1961), *Echoes of Bats and Men* (1959), *Bird Migration* (1964), *Animal Thinking* (1984), and *Animal Minds* (1992). He is best known for his discovery with another scientist that bats use echolocation and for his current investigations of whether animals think and plan.

THE EBENEZER HINCKLEY HOUSE, 1906. The handsome foursquare house behind and to the left of these two elegant ladies is said to be the first with a hopper, or hip, roof in Barnstable. Dating from the early 1700s, the roof was changed later to its present configuration. The view looks eastward along Main Street from a location near the Lothrop Hill Cemetery. (Courtesy of Donald Griffin.)

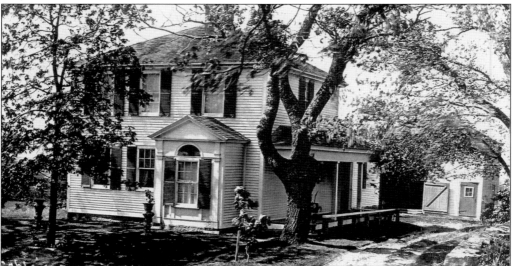

THE PACKET HOUSE, 2772 MAIN STREET. Capt. Matthias Hinckley, the great-great-grandson of Gov. Thomas Hinckley, built this house *c.* 1829. Matthias's son Francis was master of *Star of Peace, Arabia,* and *Leading Wind.* To show that a captain's life was not always an easy one, Kittredge in *Shipmasters* notes that Francis Hinckley at one point was told by the owners of the *Arabia* to use thinner paper when he wrote from New Zealand to save money. (Courtesy of the Sturgis Library.)

SALT ACRES, 2984 MAIN STREET. Built *c.* 1717, this fine old Colonial was acquired in 1867 by Capt. Robert M. Waitt, who with his across-the-street neighbor, Capt. John Wilson, sailed with Admiral Perry. Wilson was a collector of trees and in 1862 brought back a Japanese elm that he planted in Waitt's yard. The tree's circumference now exceeds 17 feet. Unfortunately, the tree is not shown here. (Courtesy of Dan Knott.)

THE CROCKER TAVERN. Built *c.* 1754 across from the Barnstable County House and next to the first courthouse, this was one of the many inns and taverns established nearby. First named Aunt Lydia's Tavern, it became known as Sally Crocker's Tavern and continued under that name until 1837. Josiah Hinckley was playing cards there in 1827, when the Barnstable County House burned, destroying 93 folios of real-estate records and three of probate records. Hinckley got a ladder and climbed to the second floor of the burning building. He later wrote that the fire looked him "full in the face and seemed to say . . . you had better stand back and make room for me."

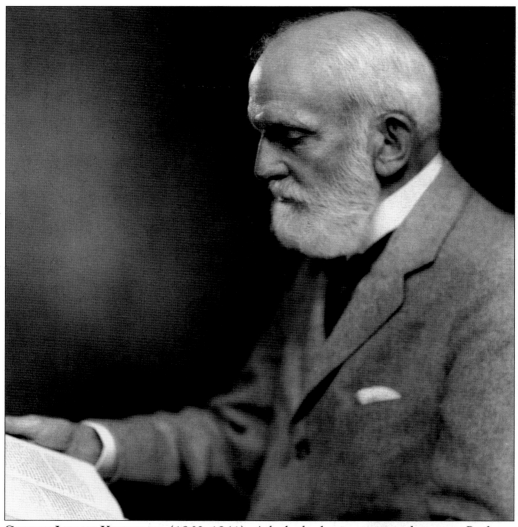

GEORGE LYMAN KITTREDGE (1860–1941). Asked why he never got a doctorate, Professor Kittredge is said to have answered, "Who could examine me?" Without identifying himself, in England he once asked a local Shakespeare expert to help him with an abstruse question about the bard. He was told that only one person in the world could answer the question: George Lyman Kittredge of Harvard. Known as "Kitty" to thousands of Harvard students, he spent summers from childhood in Barnstable. He graduated from Harvard in 1882, taught at Exeter Academy for 6 years, and was a Harvard faculty member for 48 years. He was the world's best-known Shakespeare scholar and received honorary degrees from Harvard, Yale, Brown, Chicago, McGill, Oxford, and Johns Hopkins. He authored or co-authored 13 books, including *The Complete Works of Shakespeare* (1936) and *Witchcraft in Old and New England* (1929), and was a leading authority on Beowulf, Mallory, and Chaucer. Professor Kittredge was also an omnivorous collector, and the Trayser Museum has some of the arrowheads and Native American artifacts he found on Sandy Neck. Dr. Henry MacCracken, a contemporary, paid tribute to "the eager, insatiable, omnifarious, omnilegent mind of Professor Kittredge." And he never outgrew his love for Barnstable. The photograph was taken *c.* 1932. (Courtesy of the Sturgis Library.)

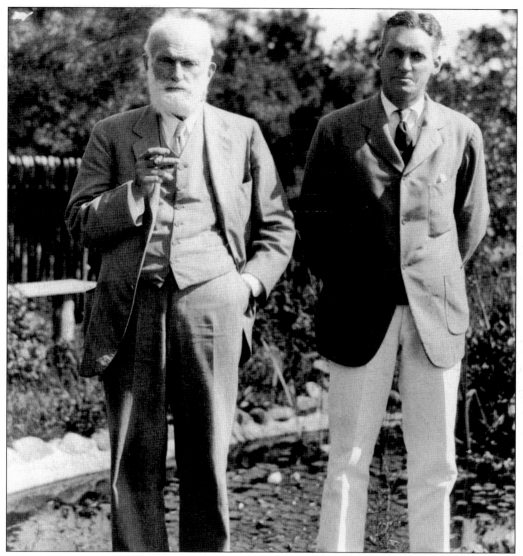

HENRY KITTREDGE (1890–1967). In his words, Henry Crocker Kittredge was "pure juice of the Cape Cod grape." The son of George Lyman Kittredge, he was born in Cambridge and summered in Barnstable from childhood. He graduated from Harvard in 1912, married Gertrude "Patsy" Livingston (another Barnstable summer regular), taught English and Latin at St. Paul's School in Concord, New Hampshire, and became the school's first lay rector. In the 1930s, he wrote his Cape Cod classics *Cape Cod: Its People and Their History* (1930), *Shipmasters of Cape Cod* (1935), and *Mooncussers of Cape Cod* (1937). In 1935, he was elected to Phi Beta Kappa and received an honorary degree from Trinity College; Yale University followed suit in 1954. He was a passionate beachcomber and duck hunter, and Sandy Neck was always an anchor to windward. Retiring to Barnstable in 1954, he was recognized as one of the Cape's best storytellers and served as a trustee of the Sturgis Library and as president of the trustees of the West Parish Memorial Foundation. After Kittredge died in 1967, the Kittredge Room of the Sturgis Library was dedicated to his memory and to the safekeeping of his collections. (Courtesy of the Sturgis Library.)

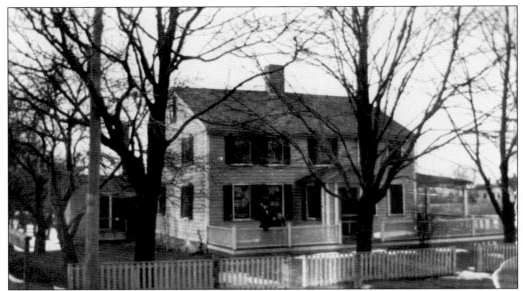

THE GEORGE LYMAN KITTREDGE HOUSE. Located next to the tracks on Railroad Avenue, this two-story full Colonial house was built prior to 1838 in Cummaquid. It was cut in three sections c. 1854 and moved by a double ox team. According to town records, the house was "followed by all the children in Barnstable." Title passed to Professor Kittredge through his mother's side of the family, who were early settlers of Barnstable. (Courtesy of Frances Bush-Brown.)

ALBERT BUSH-BROWN (1926–1994). Another accomplished academic came to Barnstable when "Bush" married Frances Wesselhoeft, Professor Kittredge's granddaughter. Bush graduated from Princeton in 1946 and taught at Massachusetts Institute of Technology. He served as president of Rhode Island School of Design and, later, as chancellor of Long Island University. An art historian, avid gardener, and fisherman, he added to local lore with his booklet *Books, Bass and Barnstable.* (Courtesy of Frances Bush-Brown.)

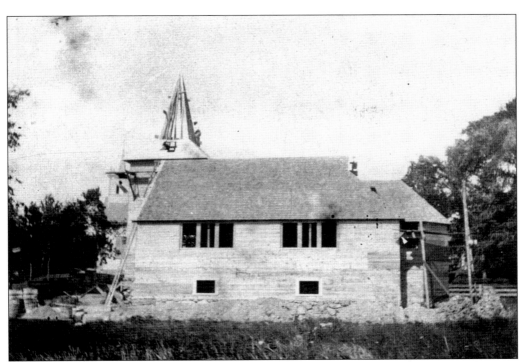

WORK IN PROCESS, C. 1890. This view shows St. Mary's being built by Leslie Jones on land given by Kearny Cobb. The first service was held on July 5, 1891. (Courtesy of the Sturgis Library.)

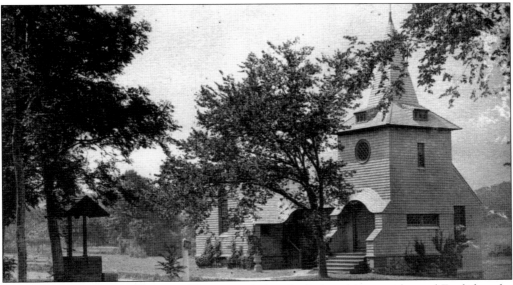

ST. MARY'S EPISCOPAL CHURCH. The original church, designed in an early rural English style, was enlarged in 1937 according to designs of John M. Barnard, a local architect. The lovely garden dates from the tenure of Rev. Robert Wood Nicholson, a former U.S. Navy chaplain who served the parish from 1946 to 1960. Further changes have been made to the church, which now serves more than 700 families. (Courtesy of Donald Griffin.)

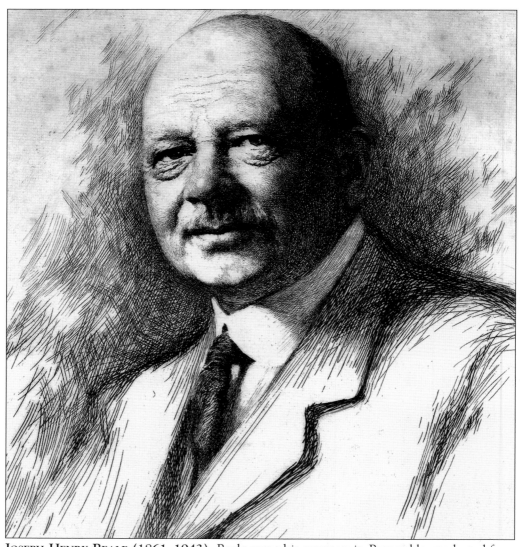

JOSEPH HENRY BEALE (1861–1943). Beale spent his summers in Barnstable, graduated from Harvard in 1882, and taught at St. Paul's School for a year. In 1887, he graduated from Harvard Law School, where he was a founder of the Harvard Law Review. He married Elizabeth Chadwick Day, daughter of Barnstable probate judge Joseph M. Day, and in 1891 began his full-time teaching career at Harvard Law School, where he remained until his retirement in 1938. Beale taught a broad array of subjects, including criminal law and conflicts of laws, and wrote many articles and 27 books. On a two-year leave from Harvard, he served as the first dean of the law school at the University of Chicago, recruiting its faculty and in effect founding that great school. He received honorary degrees from Chicago and Wisconsin (1904), Cambridge University (1921), Harvard (1927), Boston College (1932), and Michigan (1933). In 1915, when Harvard Law School, continuing its policy against admitting women, refused to admit his daughter, Elizabeth Beale (later Mrs. Basil Edwards), he opened the Cambridge Law School for women in two rooms provided by Radcliffe. Nine enrolled and were taught by Harvard Law School professors and graduate students. The school, however, lasted only two years. (Courtesy of James K. Edwards.)

ADM. FRANCIS TIFFANY BOWLES (1858–1927). Bowles graduated from the U.S. Naval Academy in 1879 and earned a degree in naval architecture from the Royal Naval Academy, Greenwich, England. He served in the U.S. Navy as a rear admiral (1901–1903) and as the navy's chief constructor. He was president of Fore River Shipbuilding and served as the assistant general manager of the Emergency Fleet Corporation. Bowles was also the second president of the Cape Cod Chamber of Commerce, serving for six years. Contemporary newspapers acknowledge his extensive contributions to Cape Cod. (Courtesy of Beatrice Magruder.)

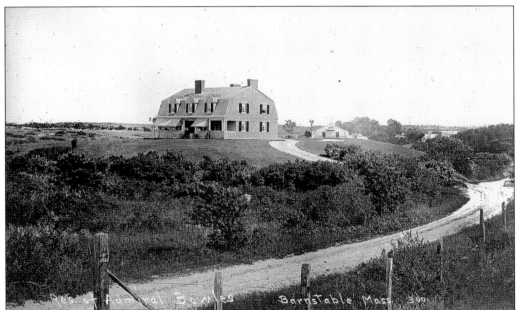

NUSHKA. Designed by Hornblower and Marshall of Washington, D.C., this early Barnstable summer house was built beginning in 1896 by Leslie Jones, a local master builder who also did St. Mary's Church and the village hall. According to the family, the total cost was $6,800. After going from window to window and exclaiming "Look! Look!" one of the workers noted that the Native American word for that expression was *nushka,* and so the house was named. The site does command an extraordinary and ever-changing view. (Courtesy of Frances Hunsaker.)

THOMAS BERRY BRAZELTON (B. 1918). After graduating from Princeton in 1940, Thomas Berry Brazelton turned down an opportunity to sing on Broadway. He finished Columbia Medical School in 1943, married Christina Lowell in 1949, and became a favorite pediatrician, professor, television star, newspaper columnist, and outstanding Barnstable neighbor. He has helped and charmed many patients, written numerous books, and achieved too many honors to list here. His major interest today is funding a charitable foundation dedicated to training providers in outreach methods for bringing medical treatment to uninsured children. (Courtesy of Beatrice Magruder.)

THE DILLINGHAM HOUSE. Dating from *c.* 1750, this hip-roofed Georgian house was originally located in Brewster and had been owned by nine generations of Dillinghams. Advertised for sale in *Antiques* magazine, it was purchased by Dr. and Mrs. T. Berry Brazelton and flaked—that is, taken apart piece by piece with each marked so it could be replaced in its original position. The reconstruction shown here was completed on family land on Commerce Road in 1953. (Courtesy of Beatrice Magruder.)

GOOD COMPANY. Mary Mortimer (left) and Edith Beale are enjoying themselves in 1901. (Courtesy of Donald Griffin.)

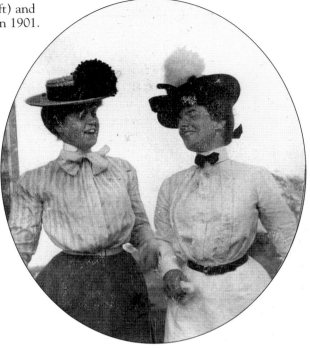

SYLVANUS BOURNE PHINNEY (1808–1899). Energetic and entrepreneurial, Maj. Sylvanus B. Phinney was an outstanding businessman and politician. In 1830, he founded (and, for years, owned) the Barnstable Patriot, Cape Cod's oldest continuing newspaper. He served as collector of customs, a political plum, under Presidents Polk, Pierce, Buchanan, and Johnson. He was also secretary of Barnstable Savings Institution; president of Hyannis Savings Bank; president of Hyannis National Bank; clerk of the Cape Cod Central Railroad; a member of the Democratic National Convention in 1844, 1853, and 1857; president of the Cape Cod Unitarian Conference; president of the Barnstable Agricultural Society; a Mason; and a major in the 1st Regiment of the Massachusetts Militia. Phinney lived in the 1800s house immediately to the east of the Trayser Museum. The barn on the premises, built in 1820, is a fine example of a Federal-style outbuilding. (Courtesy of the Barnstable Patriot.)

The Refuge, 3461 Main Street. The refuge, acquired in 1819 by Matthew Cobb, passed in 1871 to Matthew's son Francis (1837–1915). In 1911, it passed to Francis's son Richard. Francis Cobb went to sea at age 16, was grounded by sickness in Singapore, engaged in the import business, and served as U.S. consul to Singapore for many years. He is said to have boarded there with Anna Leonowens, the Anna of the musical *The King and I*. Richard Cobb was headmaster of Milton Academy.

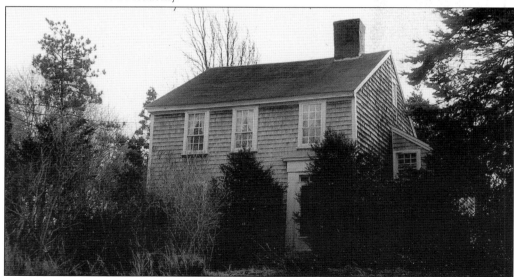

The Timothy Swinerton House, 3831 Main Street. This half-Cape was built in the 1750s probably by Ensign Shubael Dimmock or his sons, well-regarded housewrights. In the late 1850s, Timothy Swinerton's son David Easterbrook Swinerton captained the *Flying Scud*, a clipper built in Maine. Under other captains, the clipper had traveled from New York to Melbourne in 80 days and from New York to Bombay in 82 days.

Four

GROWING UP

And hand in hand, on the edge of the sand,
They danced by the light of the moon,
The moon, the moon,
They danced by the light of the moon.

—Edward Lear, "The Owl and the Pussy-Cat"

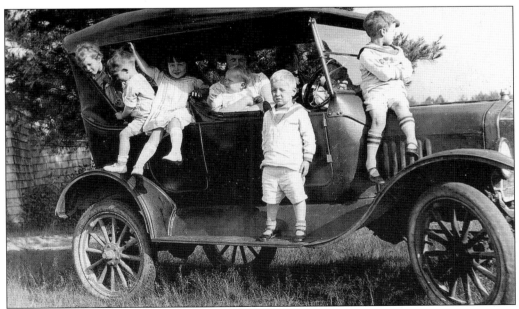

PROGENY, C. 1923. In the front seat of the Model T, the adults are Prof. Joseph Henry Beale and his daughter Elizabeth Chadwick Edwards. The children are, from left to right, Betsy Edwards, William Ashley Jr., Mary Ashley, James Edwards, Joseph Edwards, and Basil Edwards. (Courtesy of Joseph H.B. Edwards.)

BEGINNINGS. Parenting has always been a tender and occupying business. Here is Ruth Howard at the shore in 1921 with her son Bunny. (Courtesy of John Howard Jr.)

JUST LOOKING. These two boys with their father are admiring Barnstable Harbor and moored boats in the late 1890s.

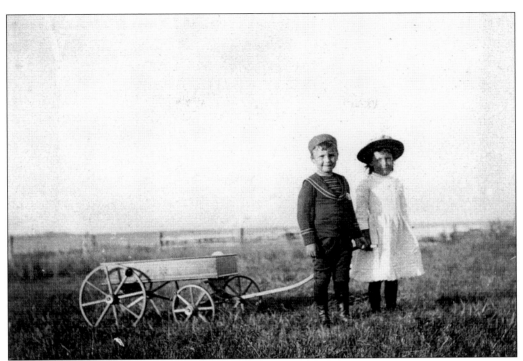

CHILDREN WITH A WAGON, C. 1890. For those growing up in Barnstable, this was not a bad way to pass time. (Courtesy of the Sturgis Library.)

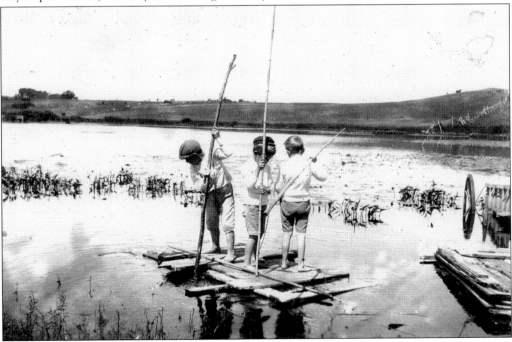

RAFTING. In this 1899 picture of boys fishing at Flax Pond in Cummaquid, note the grazed, barren landscape.

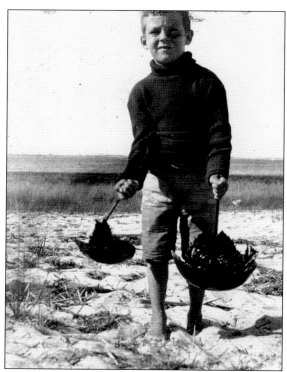

HORSESHOE CRABS. According to the picture's caption, the crabs caught by this boy in the late 1890s were "lively and heavy." These ancient creatures, now in some jeopardy, still entrance the children who find them.

HORSING AROUND, C. 1900. Mary and Sallie Sprague are seen here taking a jaunt. (Courtesy of James Calvin.)

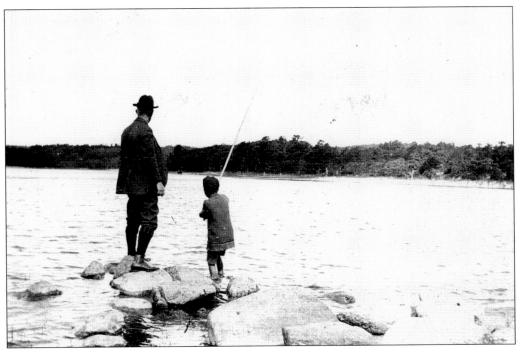

FISHING, C. 1900. A father and son are fishing at Hathaway's Pond.

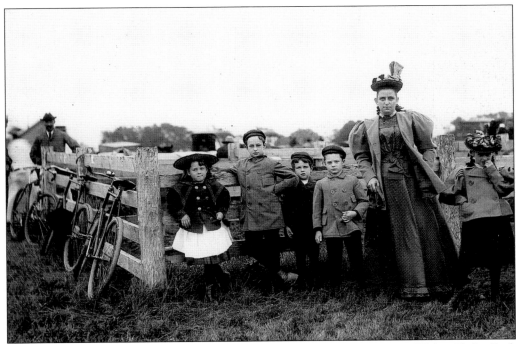

AT THE FAIR, C. 1900. From left to right are Mary Sprague, Harry Everett, Walter Tufts, Dick Everett, an unidentified friend, and Molly Tufts at the Barnstable Fairgrounds. (Courtesy of James Calvin.)

AT PLAY, C. 1900. Lucile Thayer (later, Lucile Jerauld) decorates a young male friend with her sun bonnet.

YOUNG SWIMMERS. About to test the water in 1900 are Kathleen Childs (left), H. Childs (center), and Alfred Redfield. (Courtesy of Donald Griffin.)

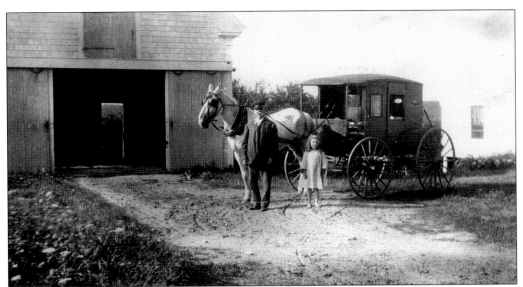

THREE FRIENDS. Nothing is known about this picture except what it tells. The barn, the driver, the bare-footed girl, the carriage, the white horse with blinders, and the wild flowers all are of interest.

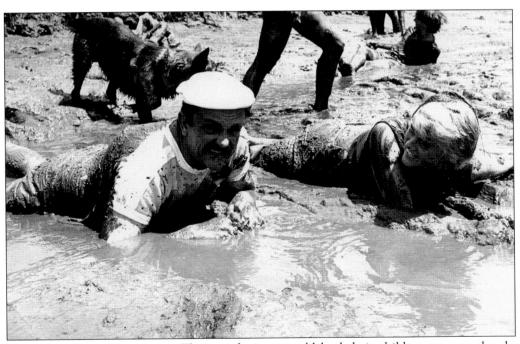

KURT AND JANE VONNEGUT. These pied pipers would lead their children on annual treks across the Great Marsh through its muddy creeks. Beginning as a romp for their extended family of eight, the long-distance mud baths were later enjoyed by 20 to 30 neighbors. This photograph was taken in 1965 after one of the "marsh tromps." In later years, Jane wrote *Angels without Wings*, and Kurt authored many well-known books. (Courtesy of Edith Vonnegut Squibb.)

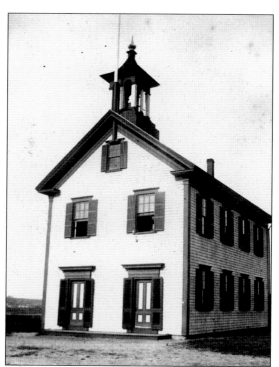

THE OLD WEST BARNSTABLE ELEMENTARY SCHOOL. This, the second school to be located on Meetinghouse Way, burned to the ground in 1902, 29 years after it was built. The cause was not determined. Pupils from Marstons Mills were transported to the West Barnstable school by barges drawn by two horses. According to the *Patriot*, the town in 1876 had 17 schools and a budget of $9,940, less than $600 per school. Teachers' monthly salaries averaged from $50 to $110 for men and $22.50 to $42.50 for women. (Courtesy of the Whelden Library.)

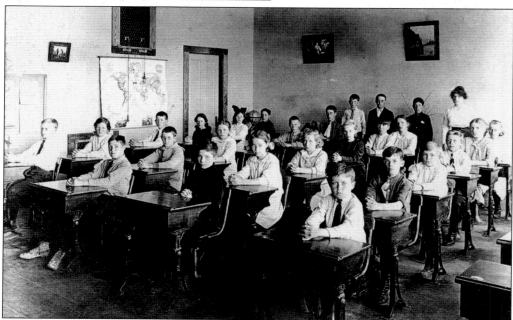

A CLASSROOM. This photograph shows the West Barnstable Elementary School *c.* 1910. Victor and Aili Maki, children of Johannes (John) Maki, are fourth and fifth from the front in the right row. Johannes had come to the United States in 1901 as a 26-year-old from Finland. His first job was planting trees along Meetinghouse Way. He later became a farmer, cranberry bog owner, and a major grower of shellfish. (Courtesy of Pauline Jarvi.)

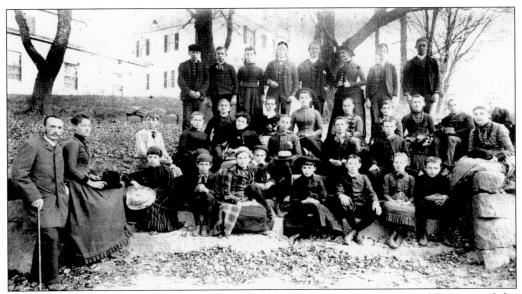

THE BARNSTABLE VILLAGE SCHOOL. The school is pictured here in 1886. (Courtesy of the Barnstable Patriot.)

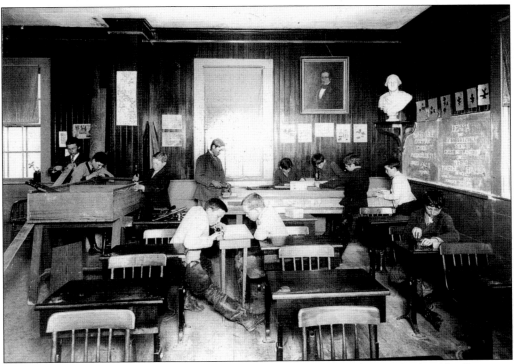

SCHOOL DAYS. Some of the things chalked on these blackboards are "Barnstable Grammar School, Massachusetts, Drama, Old Country Store, Ghost and Lantern, Drills, Music, Masonic Hall, Admission 35 Cents." The picture probably dates from *c.* 1900. The Masonic Hall was to the west and set back from the school.

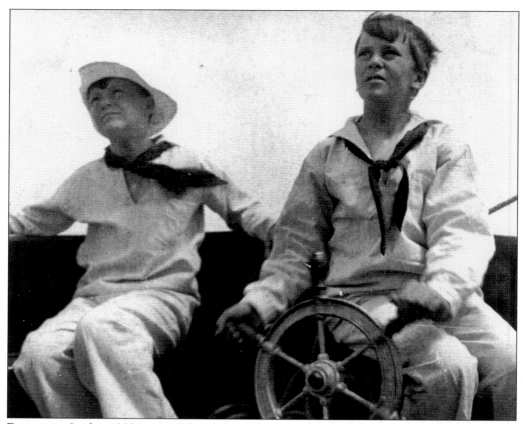

RECRUITS. In this 1902 image, John Howard (left) and Alfred Redfield, not yet in their teens, are dressed for and trying life at sea. Years later, they cruised together to Maine in a small catboat. (Courtesy of Donald Griffin.)

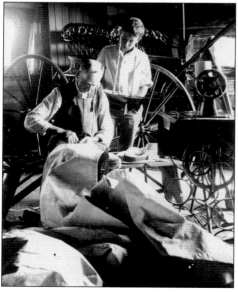

WATCHING AND WAITING, C. 1904. Young John L. Handy is watching a Mr. Cobb make sails.

SHOULD I? While she looked before she leapt, Robert Redfield got this fine picture of his teenage daughter in the early 1900s. (Courtesy of Donald Griffin.)

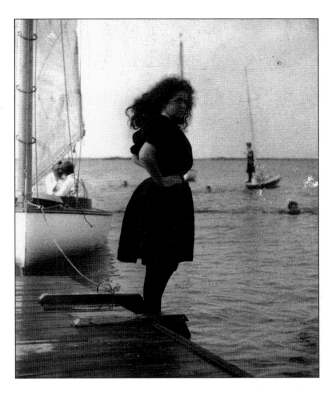

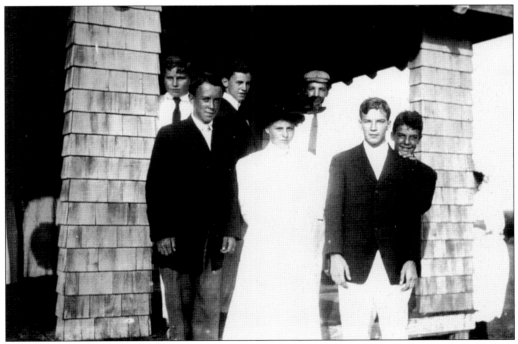

CUMMAQUID SOCIALIZING. Teenagers are dressed for socializing at the Cummaquid Golf Club in 1905.

A GONDOLIER, C. 1900. It is a calm day, and this young boatman is giving a passenger, perhaps his mother, a ride in his elegant dory. (Courtesy of Frances Bush-Brown.)

PRIZE GIVING. Each year, prizes are given at the Barnstable Yacht Club for sailing, swimming, tennis, and sportsmanship. This picture was taken in the mid-1950s. (Courtesy of Frances Bush-Brown.)

ELSIE. Armed with her parasol and dressed for swimming, Elsie Redfield is shown in 1903. (Courtesy of Donald Griffin.)

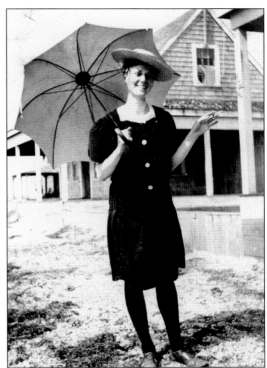

HOMEWARD BOUND. Here are three happy people walking home from Beale's Pier in 1905. The clubhouse and bathhouses show against the faint line of Sandy Neck in the background. The style of dress at the Barnstable Yacht Club has changed significantly. (Courtesy of Donald Griffin.)

ALL ABOARD, C. 1910. Kitty Bowles is perhaps inviting Frances Kittredge to join her on another trip down-Cape. We are told that at least in one instance they went as far as Provincetown, carrying wine and cigarettes to enjoy with their picnic lunch. (Courtesy of Frances Bush-Brown.)

A SAILING PARTY, C. 1912. Clarence Jones (third from left) is taking his passengers—Patsy Livingston (far left); her husband to be, Henry Kittredge; and Kitty Bowles—for a pleasure sail. The unseen photographer in the bow was Frances Kittredge. (Courtesy of Frances Bush-Brown.)

BATHERS, 1901. Dressed for a swim are, from left to right, Mary Redfield, Edith Beale, and a friend. (Courtesy of Donald Griffin.)

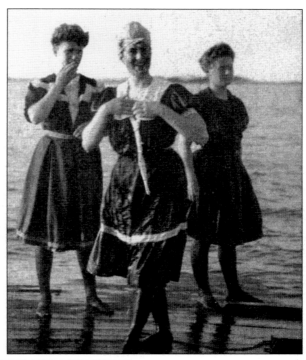

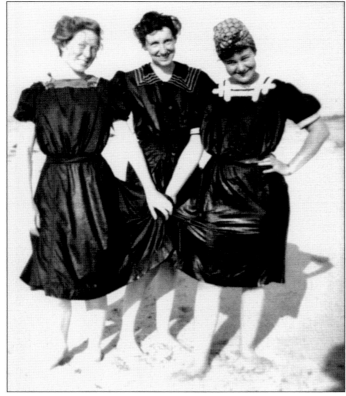

BATHERS, C. 1912. From left to right are Kitty Bowles, Frances Kittredge, and Charlotte Winslow (later the mother of Robert Lowell, the poet). (Courtesy of Frances Bush-Brown.)

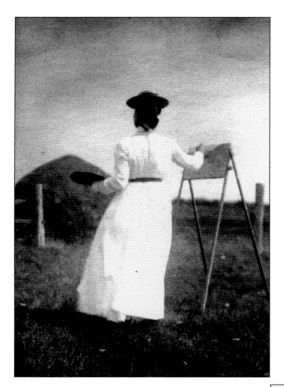

THE JOY OF PAINTING. Rich in atmosphere, this fine photograph, probably by Robert Redfield, captures his wind-blown daughter, Elsie, at her easel in 1902. It could be a painting by Homer or Benson. (Courtesy of Donald Griffin.)

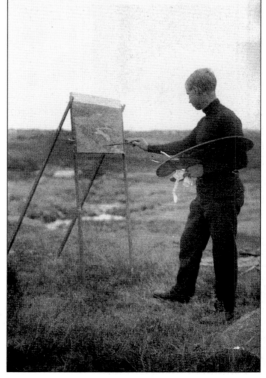

ARTIST AT WORK. Rockwell Kent visited Barnstable in 1902 and painted. Here he is working on what appears to be a marsh scene. He later became a well-known illustrator and did the dramatic ceiling in the Cape Playhouse in Dennis. (Courtesy of Donald Griffin.)

ON THE BEACH, 1909. This group enjoying the sun includes, from left to right, the following: (front row) three unidentified, Alfred Redfield, and John Howard; (back row) Dick Mann, Mary Redfield, and Molly Strong. (Courtesy of Donald Griffin.)

SEPTEMBER 15, 1903. From left to right are Mary Redfield, Mary Mortimer, Mary Easton, Lucia Howard, Edie Beale, and Elsie Redfield—perhaps thinking about the end of summer. (Courtesy of Donald Griffin.)

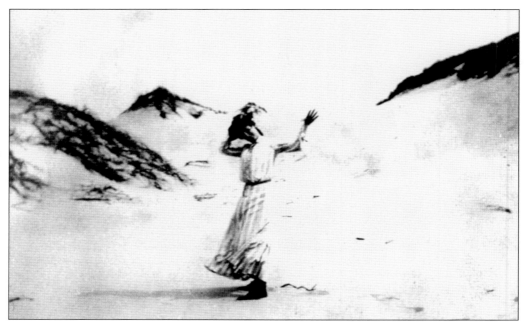

THE WAVE, C. 1900. The setting is Sandy Neck, and this is Frances Kittredge in her striped dress and plumed bonnet waving probably to her father, Prof. George Lyman Kittredge. (Courtesy of Frances Bush-Brown.)

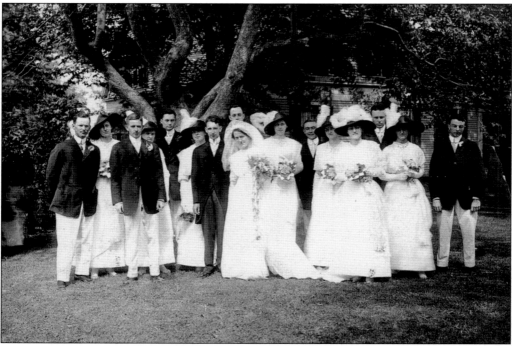

A WEDDING PARTY. In 1913, Sallie Sprague married K.H. Barnard, and this is the wedding party back at Rendezvous Lane after the pledging of vows at the Unitarian church. (Courtesy of James Calvin.)

Five

AT WORK

I hear America singing.

—Walt Whitman, "I Hear America Singing"

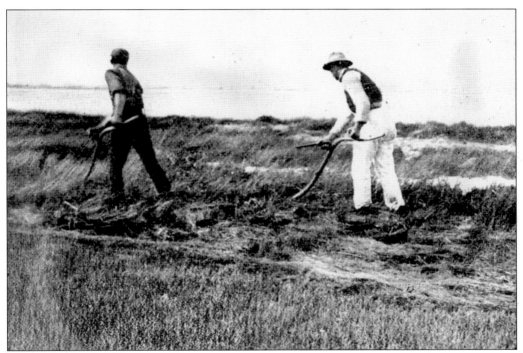

MOWING HAY. Farming and the need for livestock dwindled in economic importance with the coming of the railroad in 1854, better produce from richer off-Cape farms, the enticing dollars of tourists, and the automobile. John Maki, according to his granddaughter Pauline Jarvi, "had a farm with dairy cattle, laying hens, horses and pigs, selling milk and eggs to the neighbors. He kept many a field scythed to provide hay for his animals." William F. Bodfish (1877–1970) drove cattle from Cape Cod to a Brighton slaughterhouse and cut salt hay until the 1930s. His last draft horse died at 34 in 1968. He farmed in West Barnstable until his death at 93. (Courtesy of the Whelden Library.)

THE BURSLEY HOMESTEAD, C. 1900. This photograph by Gustavus Hinckley looks west toward the intersection of Meetinghouse Way and Main Street. The house became the Harts Ease Inn. Notice the hay being taken into the barn, the open farm country, and the wildflowers. (Courtesy of the Sturgis Library.)

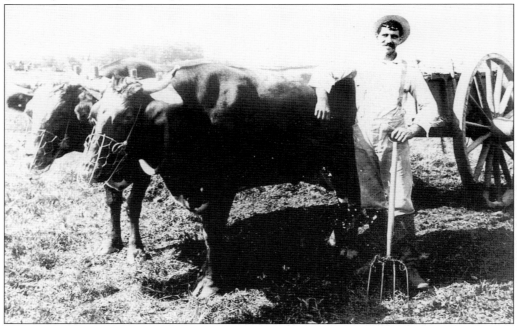

FARMING WEST BARNSTABLE. Manuel Thomas, one of West Barnstable's early Portuguese residents, is shown here with his team of oxen. He is farming land that he bought in 1908 at what is now 1525 Main Street. (Courtesy of the Whelden Library.)

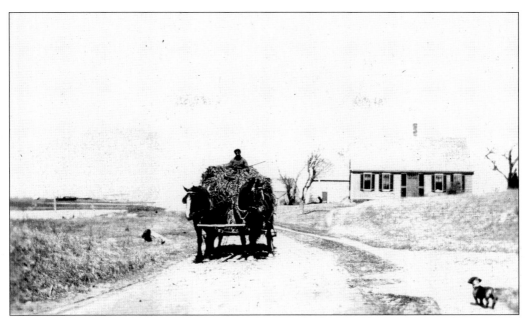

MILL WAY, C. 1910. This hay wagon is traveling south along Mill Way, leaving the Maraspin house in the right background. The house was built in 1797, and its barn, originally used as a ship's chandlery with a rope factory on the second floor, was moved from across Mill Way. (Courtesy of Frances Bush-Brown.)

HAY BURNER, C. 1925. Two Carter grandchildren—Edith (left) and Phyllis—are riding a draft horse on Grandfather Bodfish's homestead farm. (Courtesy of the Whelden Library.)

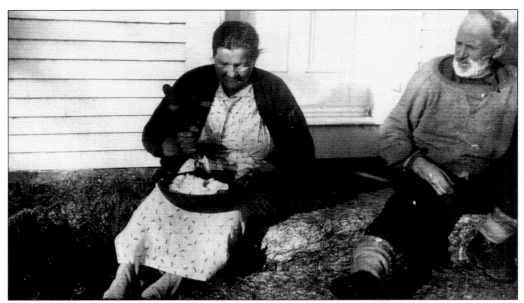

HOME BREW. In this picture from the 1920s, Johanna Maki (1875–1956) is making butter while her husband, Johannes (1875–1969), watches. (Courtesy of Pauline Jarvi.)

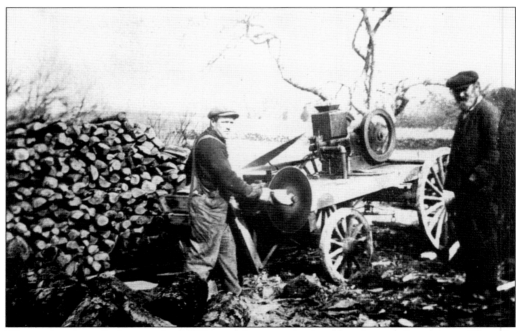

WOODCUTTERS. As late as the 1930s, wood stoves continued to be a major source of heat in West Barnstable. In this picture, Aubrey Benson (left) and Henry C. Sears are seen doing their part to supply the need. (Courtesy of the Whelden Library.)

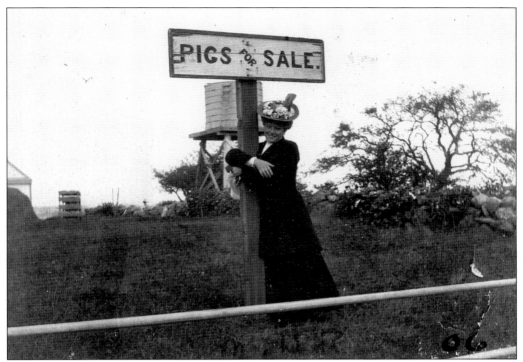

PIGS FOR SALE. In 1906, Barnstable was still farm country. Mary Redfield, a summer resident raised on Philadelphia's main line, found this sign worth a smile and a hug. (Courtesy of Donald Griffin.)

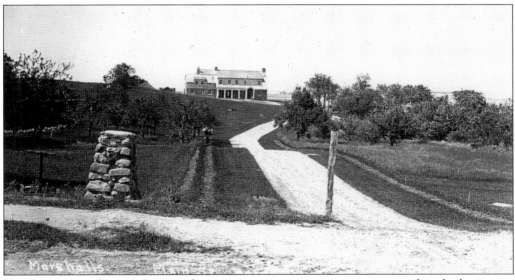

THE MARSHALL HOUSE. Increased prosperity meant more construction, and at the beginning of the 20th century, several large summer houses were built in Barnstable. Leslie Jones built this house for the Marshall family in 1904 on a commanding site acquired from the Beale family, overlooking the harbor, Sandy Neck, and Beale's Pier. The Marshall land has now been subdivided and includes a number of houses with more in prospect.

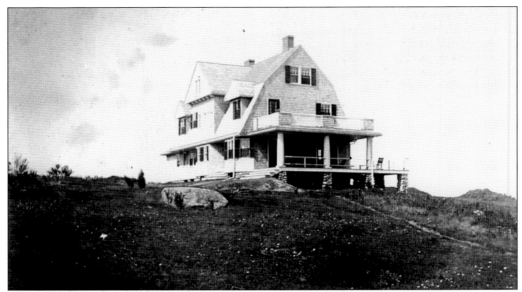

THE HUSSEY HOUSE. In 1904, this summer house was built for Rev. Alfred Rodman Hussey and his family on a high, waterfront parcel at the end of Scudder Lane. It overlooks the harbor and is reminiscent of similar houses of the period built in Wianno and elsewhere along the Cape's south shore.

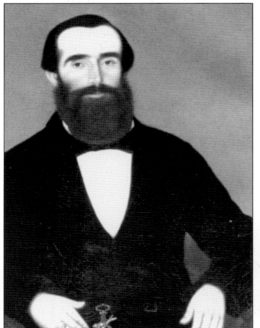
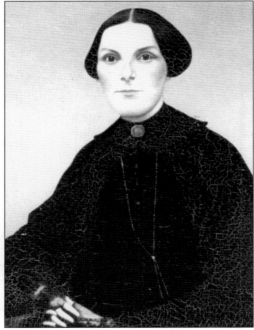

THE CROCKER PORTRAITS. Capt. Josiah Crocker (1823–1868) of West Barnstable commanded the clipper ship *Raven*, which in 1853 raced six other clippers some 15,000 miles from Boston round Cape Horn to San Francisco, placing second in 119 days. Captain Crocker sat for this portrait in China in 1863 and had the portrait of his wife, Pamelia Allyn Howland Crocker (1826–1882), painted from a photograph. (Courtesy of the Whelden Library.)

LOADING, THE LATE 1800S. This tall ship, with its cargo of lumber, is perhaps docked at Rendezvous Creek, where Josiah Hinckley had a wharf and lumber storehouse. (Courtesy of David Crocker.)

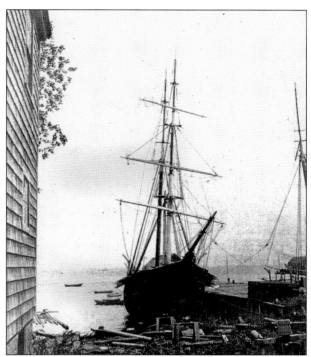

A SCHOONER, C. 1890. Photographs of coastal sailing vessels in the harbor are rare. This is thought to be Capt. Ensign Jerauld's *Bloomer*, a former packet. At one point, a round trip to Boston cost $1.50. Capt. Mathias Hinckley and Capt. T. Percival (with the backing of Daniel C. Bacon) built the ship *Mail* to be used as a Boston–Barnstable packet. In 1837, both captains raced Yarmouth's Commodore Hull to Boston, arriving in six hours and winning by three lengths. (Courtesy of the Sturgis Library.)

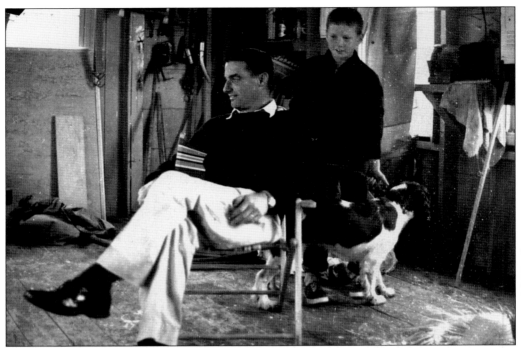

SHIPBUILDING. Capt. William Lewis had a shipyard on the west side of Maraspin Creek, where he built several schooners used as packets for the Boston–Barnstable run. His largest ship was the 186-ton brig *Cummaquid*, launched in 1836. The boatbuilding tradition in Barnstable has been continued by Bunny Howard, shown here in his boat shop with David Bush-Brown *c.* 1955. (Courtesy of Frances Bush-Brown.)

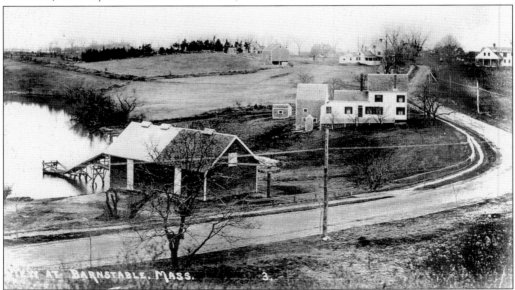

THE POND VILLAGE ICEHOUSE. The Coggins Pond icehouse was built *c.* 1865 and served the community until its removal in the late 1930s. Barnie Hinckley and brothers Albert and Chester Jones cut and delivered ice from here. (Courtesy of David Crocker.)

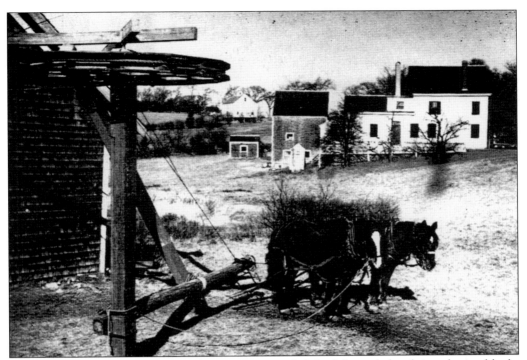

HORSEPOWER. Horses hitched to the capstan provided the lift needed to bring the ice blocks up the conveyor to street level. (Courtesy of David Crocker.)

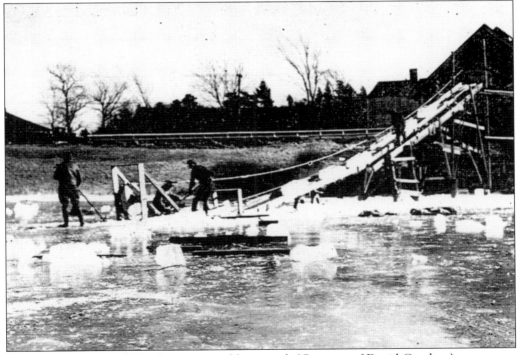

CUTTING ICE. Ice is shown being cut and harvested. (Courtesy of David Crocker.)

THE FREEZER. The original building partially burned and was substantially rebuilt in 1939. Commonly known as the Freezer, the facility was used for many years for temporary storage of fish and cranberries and making ice in 300-pound blocks. (Courtesy of Jim Ellis.)

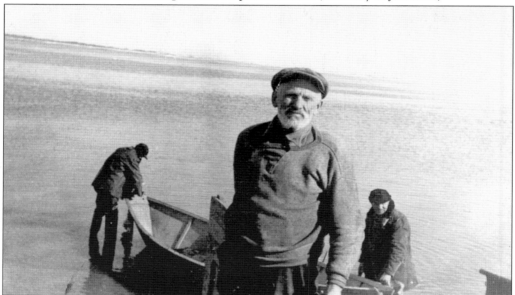

BARNSTABLE CLAMS. In the 1930s and 1940s, John Maki was seeding clams and had 50 to 75 men digging steamers and quahogs that were driven in his two Reo trucks to markets in Boston, on the North Shore, and in Providence. He had come a long way since his arrival at 26 from Finland in 1901. (Courtesy of Pauline Jarvi.)

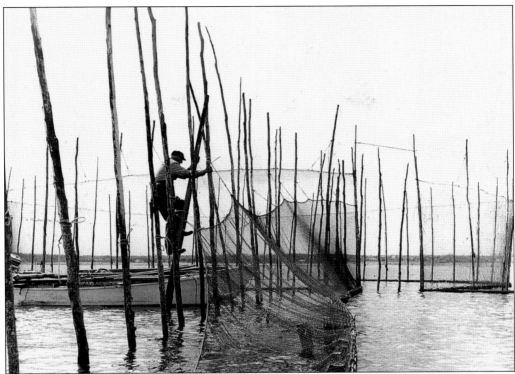

TRAP FISHING. Carbon-dated pilings from Barnstable confirm that Native Americans used fish traps 400 years ago. In this 1950s view, Shirley Lovell is tending his shallow-water fish weir south of Mussel Point. (Courtesy of Dr. Tony Lovell.)

HAULING IN. Mike Goulart and Adam Rupkis set their two weirs several miles west of the harbor entrance. Here, their crew are gaffing in a giant tuna. The net has been compressed into a small area restricting the fish's ability to move. The crew members are, from left to right, Merle Marshall, Al Van Knowe, Joe Neves, and Mike Goulart (with only his hat showing). In the 1940s, there were six trap boats working out of Barnstable. The industry died here in the late 1950s. (Courtesy of Jim Ellis.)

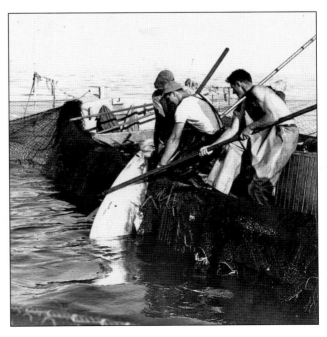

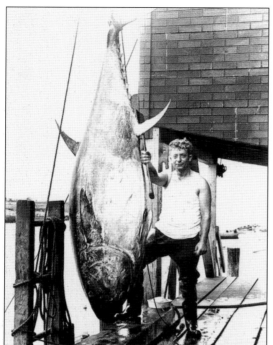

A GIANT TUNA. This big bluefin, shown with Tony DiMartino, was caught in 1952 in Mike Goulart and Adam Rupkis's weir. The fish probably weighed 850 pounds. Tony had his own fish traps, but also his P & T Company bought and transported fish to the New York market. On very good days, Mike and Adam brought in over 150 barrels (22,500 pounds) or more of mackerel with smaller quantities of whiting, squid, and butter fish. (Courtesy of Jim Ellis.)

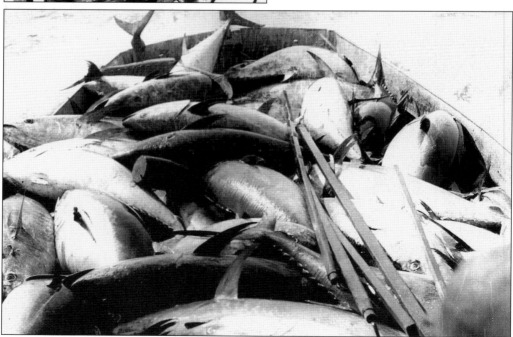

A FULL LOAD. This is a near capacity load of 300- to 400-pound tuna caught by Mike Goulart and Adam Rupkis in 1952. Jim Ellis, one of the crew, worried about being swamped when a big motorboat passed them in the harbor. Lying on top of the catch are the wooden gaffs used to haul the fish to the boat and the wooden mallet used for the kill. The *Patriot* of August 16, 1948, reported a single catch of 336 tuna. (Courtesy of Jim Ellis.)

WHAT'S THIS? Curiosity has always shielded fisherman from boredom. The 100-pound sturgeon caught in 1960 in John Vetorino's fish trap north of Sandy Neck was the third caught in 15 years. Anglers who wanted to catch sturgeon in Cape Cod Bay would require lots of patience. From left to right are the following: (front row) Tom Vetorino and Wally Whennan; (back row) Tony Lovell (a cardiologist today) and Jack Vetorino. (Courtesy of the Barnstable Patriot.)

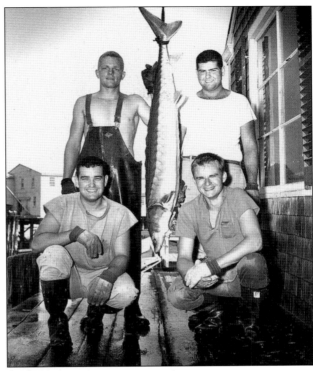

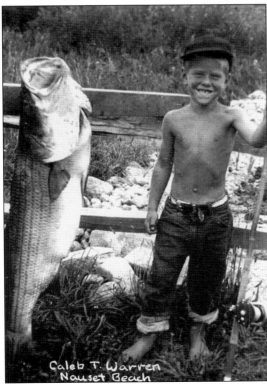

Caleb T. Warren
Nauset Beach

A STRIPED BASS. Caleb Warren poses in 1956 with a good striped bass caught at Nauset Beach but eaten in Barnstable. George Warren, Caleb's father, is one of our best local sportfishermen. Bass and bluefish caught by private and charter boats out of Barnstable are the principal catch today. (Courtesy of Caleb Warren.)

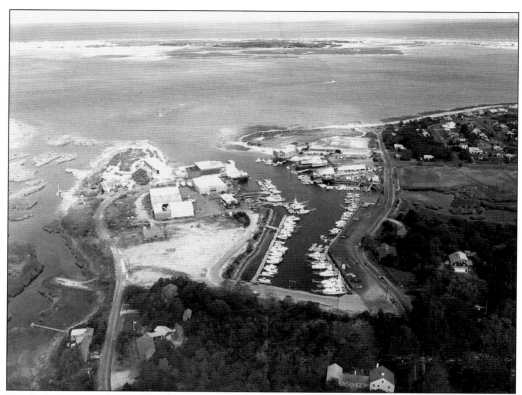

THE MARINA, C. 1974. This aerial view looks north over Barnstable Harbor and Sandy Neck to Cape Cod Bay. It shows the Freezer and the fish cannery to the left. Also seen are the public beach at the end of Mill Way, the marina (with slips for small pleasure craft and a few charter boats), and post–World War II development.

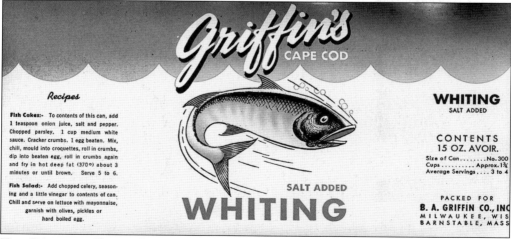

THE CANNERY. The small facility west of the Freezer canned whiting, herring, mackerel, and product for mink farms. Business there started in the early 1940s and stopped in the late 1950s or early 1960s. One of the cannery's labels is shown here. (Courtesy of Jack Hill.)

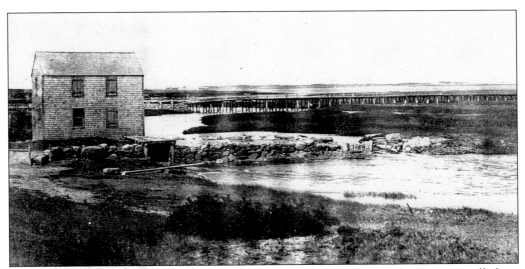

THE BLISH MILL. In 1658, Abraham Blish is said to have established a tidewater gristmill along Maraspin Creek to the west of the road still named Mill Way. This newly discovered photograph from 1890 shows clearly the sluiceway through which the tide flushed to turn the millstone that ground grist for the colonists. The Blish Milling Company of Seymour, Indiana, millers of spring and winter wheat, advertised as late as 1918 that its business began with the Barnstable mill and had been run by nine Blish generations. Also shown is the plank bridge used in 1890 to cross Maraspin Creek. (Courtesy of the Sturgis Library.)

THE SALTWORKS. In 1804, Loring Crocker Sr. (1774–1841) started his saltworks north of Commerce Road. By 1841, there were 17,000 running feet of vats producing salt and glauber salt. The business was continued by his sons, Loring Crocker Jr. and Nathan Crocker, and after 1856, by Loring alone. The last salt was produced in 1872. Abraham Blish's mill is visible at the right. (Courtesy of David Crocker.)

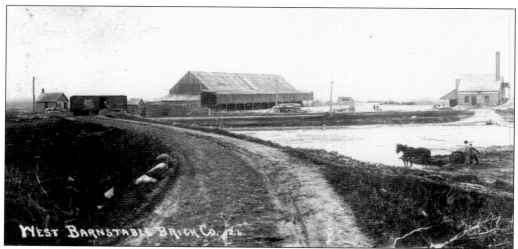

THE WEST BARNSTABLE BRICK COMPANY. The brickyard was established in 1878 by Benjamin F. Crocker, Noah Bradford (the son of a potter who had made bricks on the site in the 1860s), Levi Goodspeed, and Charles Crocker. In 1887, a new company was formed with Benjamin Crocker as president, William F. Makepeace as secretary, and A.D. Makepeace as treasurer. Emilio R. Silva (nicknamed "Frank") was foreman throughout the company's history. Thomas Arden bought the business in 1925 and modernized it, converting to electric power. For reasons not fully understood, the operation failed in the early 1930s. (Courtesy of the Barnstable Patriot.)

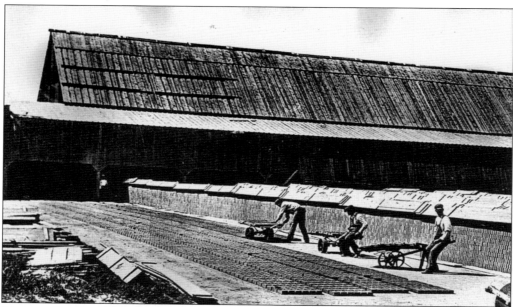

MAKING BRICKS. Manufacturing bricks, when the operation was going full tilt in the late 1880s, took from 7 to 10 days. According to a newspaper article about work at the yard, 10 cords of wood were used for every 26,000 bricks, and 100,000 bricks could be made in a day. When bricks were baking, the fires burned day and night. About 25 were employed in work that was not without danger. In 1907, Elias Kaihlainen was buried in an accident when the clay pit was being extended. (Courtesy of the Barnstable Patriot.)

ABEL D. MAKEPEACE (1852–1913).
Makepeace came to the Cape in 1854 at age 22 and started farming. His interests turned to large-scale cranberry production, and in 1874, he began accumulating bogs. Cranberries were believed to protect against scurvy, so the growth of the industry coincided with the clipper ship era, when scurvy posed a serious threat. By the late 1880s, Makepeace was the largest producer. Widely respected as a businessman, he also served as treasurer and, at one point, owner of the Barnstable Brick Company. He was also a director of the Hyannis National Bank, predecessor of Cape Cod Bank & Trust. (Courtesy of Betty Nilsson.)

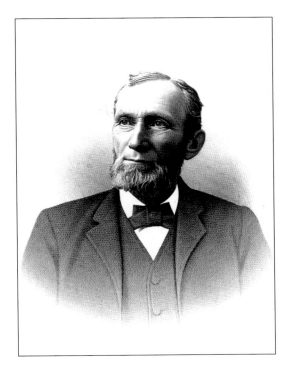

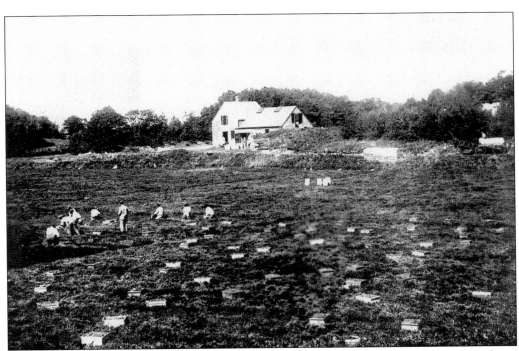

SPRUCE POND BOG, C. 1900. Zebina Jenkins, owner of this West Barnstable bog and cranberry house, is shown here standing and directing his pickers. (Courtesy of the Whelden Library.)

THE AUTOMOBILE. Cars came to the Cape in the early 1900s. Here sits Mrs. E.A. Handy in her horseless carriage, perhaps a "merry Oldsmobile." She wrote several cookbooks, including *What We Cook on Cape Cod*, published in 1911 with an introductory poem by Joseph Lincoln. She enjoyed good food, a trait inherited by her progeny.

KENT'S GARAGE. This garage and gas station was established after the Kent blacksmith shop and livery stable burned. The garage was located where the post office is now. (Courtesy of the Barnstable Patriot.)

Six
FUN AND GAMES

*Believe me, my young friend, there is nothing—absolutely nothing—
half so much worth doing as simply messing about in boats.*

—Kenneth Grahame, *The Wind in the Willows*

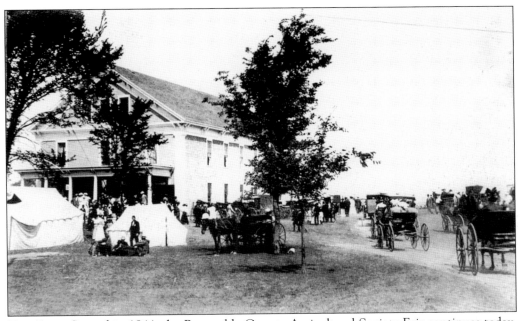

THE FAIR. Started in 1844, the Barnstable County Agricultural Society Fair continues today. The fair was held in Barnstable Village until 1931 with sulky racing, baseball, display tents, ice cream, and other treats for the happy crowds. After the original Exhibition Hall was destroyed in a gale, the second (shown here) was dedicated on October 15, 1862. It burned 123 years later. Vegetables were shown on the ground floor, and arts and crafts were on the second. Here the crowds draw near.

PRIZE RIBBONS. Shown are prize ribbons awarded at the fair and nontransferable membership cards for the Barnstable County Agricultural Society.

THE TRACK. Note the grandstand with flags flying and the judging stand on the right.

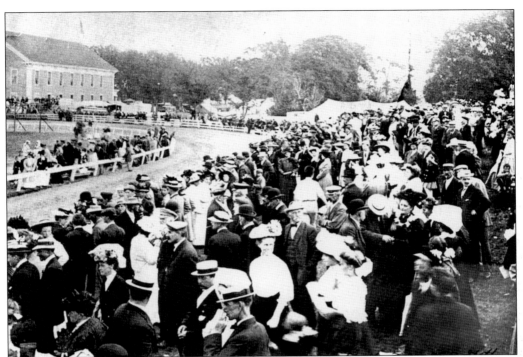

SPECTATORS. Pictured in the early 1900s is a crowd happily anticipating the sulky races. (Courtesy of the Barnstable Patriot.)

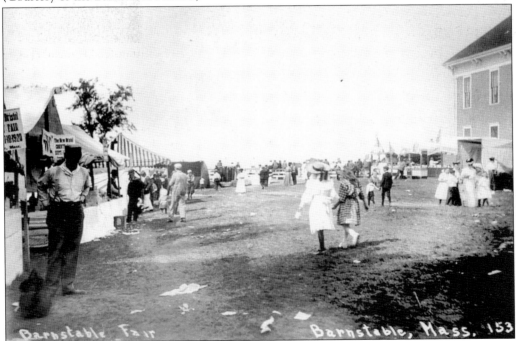

YOUNG LADIES AT THE FAIR. This well-dressed pair is walking toward the races between the display tents and the Exhibition Hall on their right.

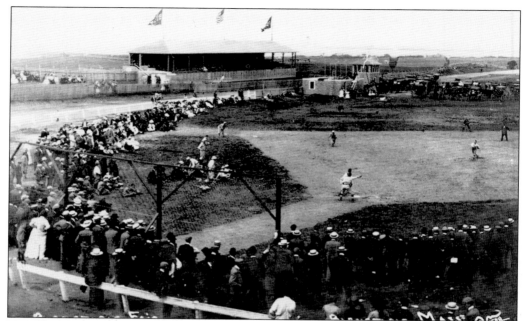

THE FAIR. Baseball was an added attraction at early fairs. (Courtesy of the Barnstable Patriot.)

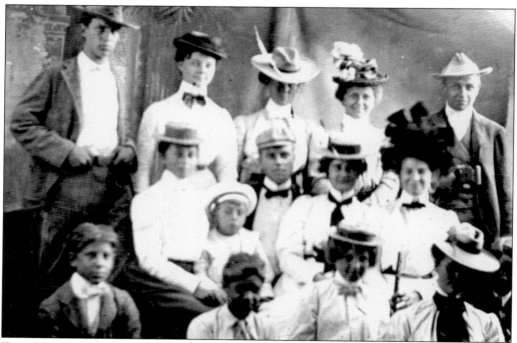

THE COUNTY FAIR. Available entertainment in August 1899 included photographers who took group and individual pictures. This photograph may have been taken by Moloney Studio, 219 Hanover Street, Boston. (Courtesy of Donald Griffin.)

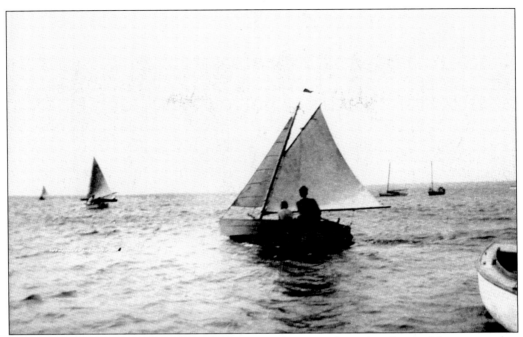

SMALL-BOAT SAILING. Notwithstanding mean tides exceeding nine feet and low water that approaches no water, the harbor has always been a sailor's delight if his boat is small and has a shallow draft. Donald Griffin and a friend are heeling in the *Peanut* in a snappy breeze in the 1930s. (Courtesy of Donald Griffin.)

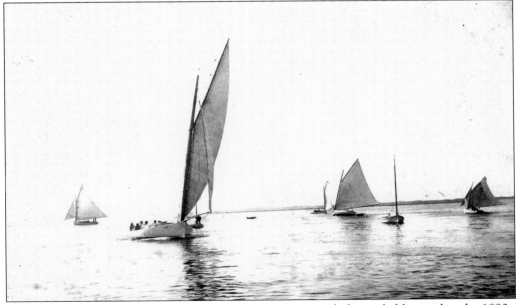

A CATBOAT RACE. These large cats, with their bowsprits and jibs, probably raced in the 1890s. The photograph was taken by Frank Sprague, a source of many Barnstable scenes developed from glass plates. A number of these plates were contributed to and are owned by the Barnstable Historical Society.

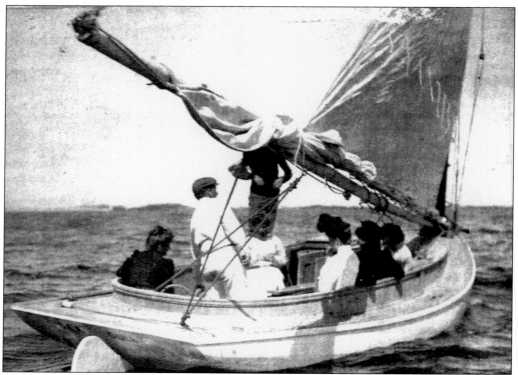

DAY SAILING, 1900. This well-dressed party of seven is off for a sail with a reef that appears overcautious in view of the moderate sea. The boat is the *Sea Gull*, and the skipper is thought to be Clarence Jones. (Courtesy of Donald Griffin.)

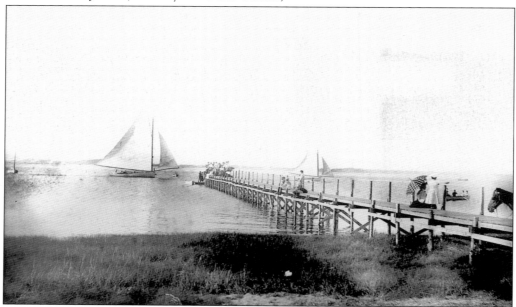

RACING AT BEALE'S PIER, THE 1890s. Note the crowd at the end of the pier, the large catboats with bowsprits and jibs, and the interested horse.

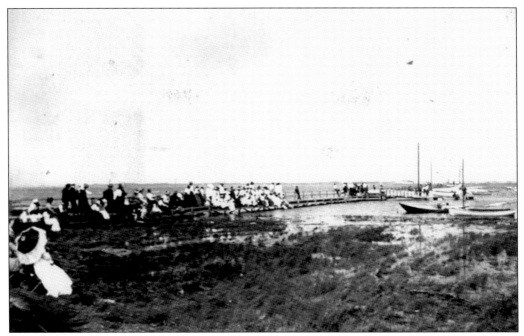

BEALE'S PIER. This photograph, in its album, was captioned, "Water sports, Beale's Pier 1902." The picture is of interest because it shows well-attended activities at Beale's Pier before establishment of the Pier Association in 1905.

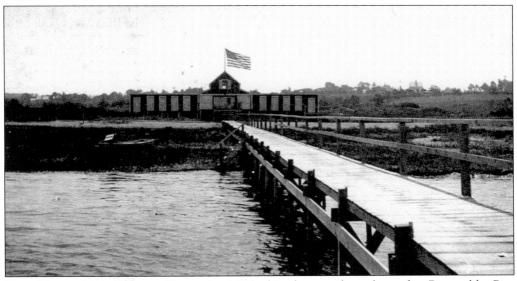

THE BARNSTABLE YACHT CLUB. In 1905, friends agreed to form the Barnstable Pier Association for "the encouragement of yachting, aquatic and athletic sports and social activity." The charter members were Joseph H. Beale, Laurence Mortimer, F.F. Chase, Oscar A. Iasigi, Walter Tufts, and Robert Redfield. In 1914, Arthur M. Beale conveyed the land, pier, and bathhouses to trustees with power to sell to the association. Francis T. Bowles, successor trustee, completed the sale to the association in 1927, two years after the group was incorporated. In 1930, the name was changed to the Barnstable Yacht Club. (Courtesy of James K. Edwards.)

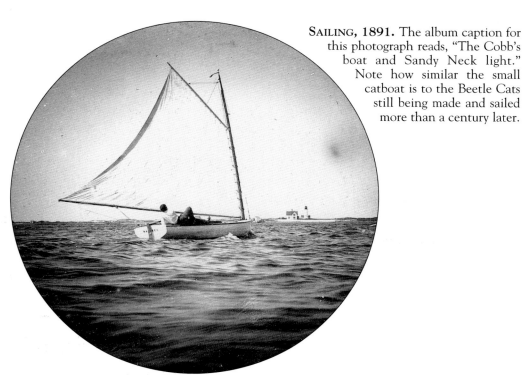

SAILING, 1891. The album caption for this photograph reads, "The Cobb's boat and Sandy Neck light." Note how similar the small catboat is to the Beetle Cats still being made and sailed more than a century later.

RACING BEETLE CATS, C. 1933. After due deliberation, a committee of Barnstable Yacht Club members recommended the purchase of Beetle Cats for the club's class boat. Donald Griffin bought the first one for Barnstable in 1932. At that time Beetles were made by Carl Beetle, who later sold his business to Concordia. While the fleet dwindled to three boats during World War II, at one time there were more than 30, and there are still around 20 in the harbor. These are two of the early boats, Parker Kuhn's *New Deal*, No. 4, passing and stealing the wind from Donald Griffin's No. 5. (Courtesy of Donald Griffin.)

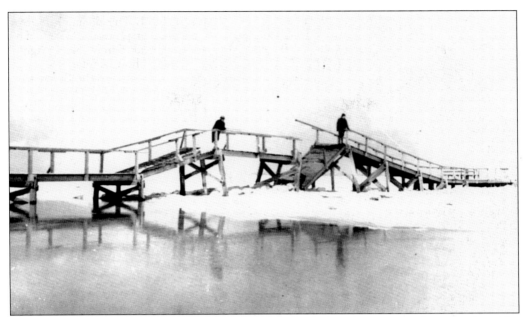

THE DAMAGED PIER. While the harbor has been known to freeze over, the sweeping tides make that a rare occurrence. On the other hand, in any cold winter, tide-lifted and driven ice can cause major damage as it did to the Barnstable Yacht Club pier in 1936. (Courtesy of Donald Griffin.)

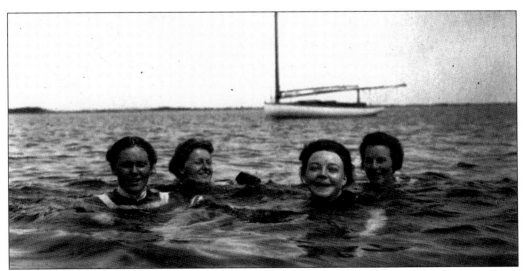

YOU COME, TOO, 1899. The water in Barnstable has always been brisk and refreshing. From left to right are Elsie Redfield, an unidentified woman, Edith Coyle, and Edith Beale. (Courtesy of Donald Griffin.)

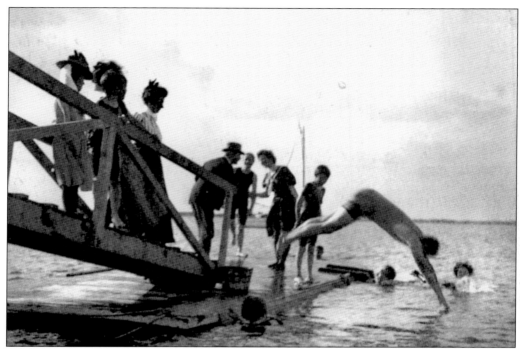

HIGH DIVING. Except for the elegance, this is a picture that could have been taken yesterday. In fact it was taken in 1900, probably by Robert Redfield. (Courtesy of Donald Griffin.)

LADIES, TOO. Ample bathing dresses worn by ladies in 1899 were no bar to high diving. (Courtesy of Donald Griffin.)

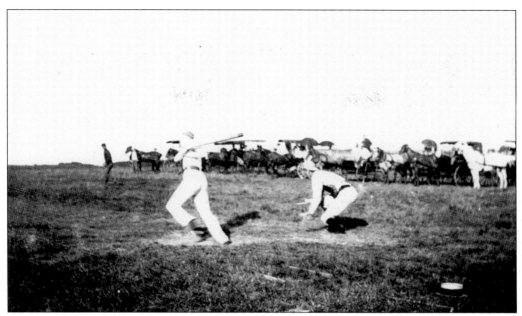

It's a Hit! This bit of action took place in a ball game played at the end of Rendezvous Lane in 1888 or 1890. (Courtesy of the Sturgis Library.)

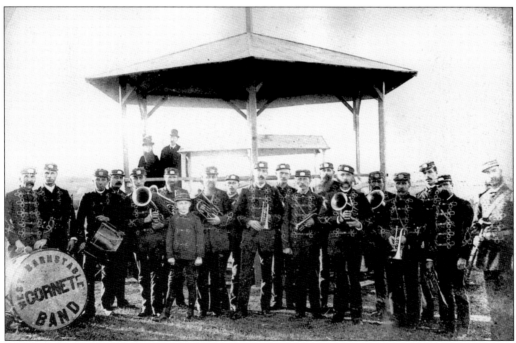

The West Barnstable Cornet Band, c. 1890. Many of West Barnstable's most noteworthy citizens participated in this band. The gazebo was a moving feature of the local landscape; it was once located where Lombard and Willow intersect. One of the cornets was given to and is still prized by the Whelden Library. (Courtesy of the Whelden Library.)

117

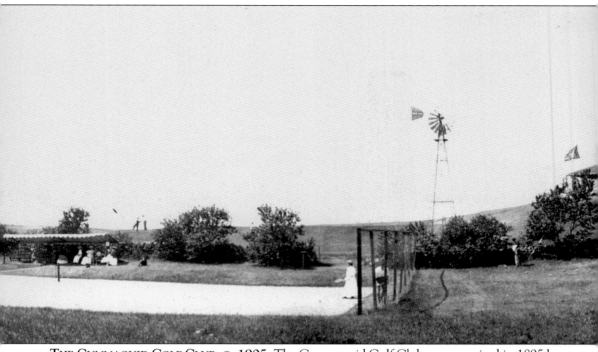

THE CUMMAQUID GOLF CLUB, C. 1905. The Cummaquid Golf Club was organized in 1895 by Dr. Gorham Bacon and a group of enthusiasts from Cummaquid, Barnstable, and Yarmouth, including John Simpkins, Henry C. Mortimer, Thomas C. Day, Thomas Thatcher, and David Crocker. It is said to be the oldest course on Cape Cod. The first clubhouse was built in 1896,

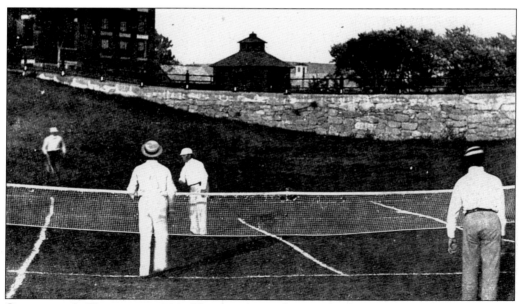

GENTLEMEN'S TENNIS, C. 1890. These men are playing on what appears to be a grass court along Railroad Avenue. The brick jail that burned in the 1930s can be seen in the background on the left. (Courtesy of the Sturgis Library.)

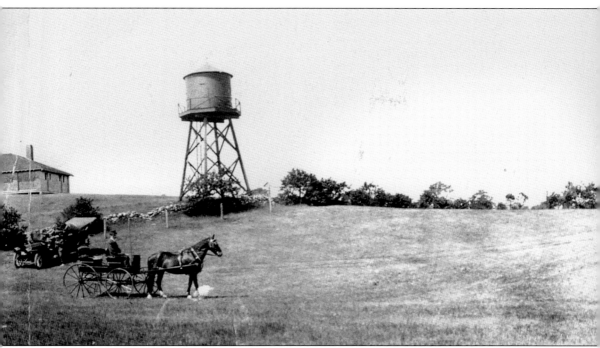

and for many years, the course had only nine holes. More than 150 private houses built since World War II surround the course today. Hitting a tennis ball was also favored in the early 1900s. There were courts at the Cummaquid Golf Club and at the houses of the Beales, Kittredges, Bowles, and Handys.

COOLING OFF, C. 1890. Temporary sunshade, tennis rackets, and elegant hats add charm to this picture, but we will never know to what extent the special touches were W.R. Bascomb's props. (Courtesy of the Sturgis Library.)

THE BARNSTABLE COMEDY CLUB. This building, constructed in 1912 by Leslie Jones, originally served as the village hall. For years, it was used for socials, wedding receptions, the annual Firemen's Ball, theatricals, club meetings, and children's Christmas parties. Acquired in 1927 by the Barnstable Woman's Club, it was sold to the Barnstable Comedy Club in 1962, and the sales proceeds were used for scholarships and the Sturgis Library. Barnstable Comedy Club theatricals in the building date back to 1922 and continue today.

PERFORMERS. These performers from an early Barnstable Comedy Club production are, from left to right, Peg Knott, Kathleen Sprague, and Mary Sprague. (Courtesy of James Calvin.)

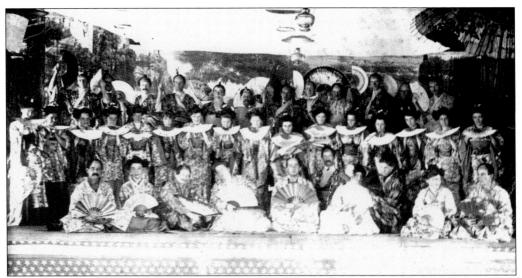

THE MIKADO. The Barnstable Comedy Club gave the Mikado in 1934. From left to right are the following: (front row) F.W. Sprague, F. Sherman, H. Beale, W.F. Gorham, and ? Hooper; (middle row) B. Lothrop, C. Phinney, C. Lothrop, E. Beale, H. Phinney, E. Crocker, V. Cash, M. Loring, E. Davis, M. Howland, G. Jones, and N. Brown; (back row) W. Hawes, C.F. Jones, T. Mahoney, A. Beale, A.F. Sherman, D. Seabury, G. Seabury, H. Ryder, A. Crocker Sr., H. Hinckley, A. Brown, T. Crocker, and M. Howes. (Courtesy of the Barnstable Comedy Club.)

A PICNIC. The album in which this photograph appeared indicates that Dr. Susanna Otis, a Mrs. Dwight, Mr. and Mrs. E.A. Handy, and others enjoyed this picnic in 1905. Amy Handy is on the left, and Edward is in the light suit by the car.

CHERRYSTONES, ANYONE? This fine photograph captures three women digging clams between swims in 1900. The site is the end of Rendezvous Lane. (Courtesy of James Calvin.)

CLAMBAKES. As they are today, clambakes were a favorite pastime in the early 1900s.

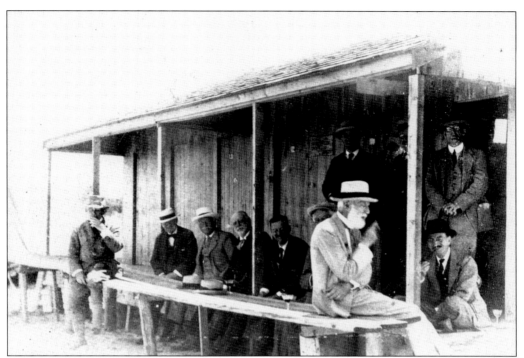

THE CLAMBAKE. On July 19, 1924, Boston's Club of Odd Volumes, of which Admiral Bowles was president, had a clambake on the admiral's beach in Barnstable. The occasion provoked a curious, learned, and lavishly illustrated pamphlet entitled *The Bake at Barnstable, A Cape Cod Piece.* The small volume notes that there were clams, lobsters, and "sundry bottles of a non-alcoholic liquid of agreeable taste, as to the provenance of which the Admiral was reticent, not to say evasive. From the labels their domicile of origin appears to have been Scotland." Happily, the drink was nonalcoholic, because the Volstead Act and prohibition ruled the land. The photograph shows Professor Kittredge in front toward the right, Admiral Bowles at the extreme left and other eminent Boston scholars. (Courtesy of Beatrice Magruder.)

OUT IN THE COLD. Dressed in warm clothes, these hearties are enjoying their Sandy Neck stroll in the 1930s. From left to right, they are as follows: (front row) Edith Carter Lampi and Phyllis Carter Bassett; (back row) Francis Marsters, Julia Marsters, William F. Bodfish, Martha Bodfish Dickey, and Rubin Marsters. (Courtesy of the Whelden Library.)

A BARNSTABLE CYCLIST. The Sturgis house, seen in the background on Main Street in Barnstable Village, burned in 1904. The building on the right is 3254 Main Street. Note the light traffic. (Courtesy of the Barnstable Patriot.)

A WEST BARNSTABLE CYCLIST, c. 1900. The lady with the large bike and small hat is Edith Holway Fish, wife of Charles Fish. They lived at 431 Willow Street in West Barnstable. The photograph was taken by a Pawtucket, Rhode Island firm. (Courtesy of the Whelden Library.)

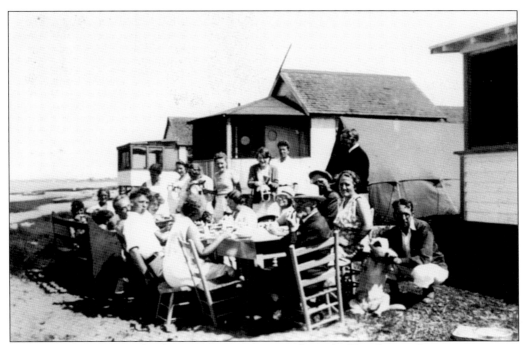

LUNCHTIME, C. 1920. The three summer cottages at the end of Rendezvous Lane were a source of pleasure and a world apart for their occupants and friends. Outdoor lunches were one of the common summer diversions. (Courtesy of James Calvin.)

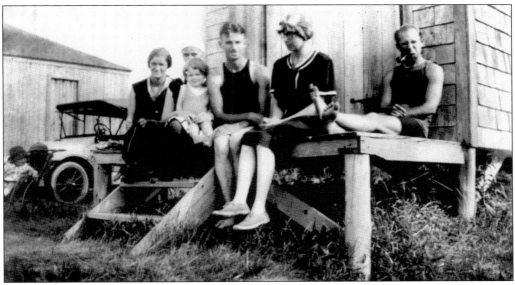

A DAY ON THE SHORE, C. 1918. A group relaxes on the shore at Rendezvous Lane. (Courtesy of James Calvin.)

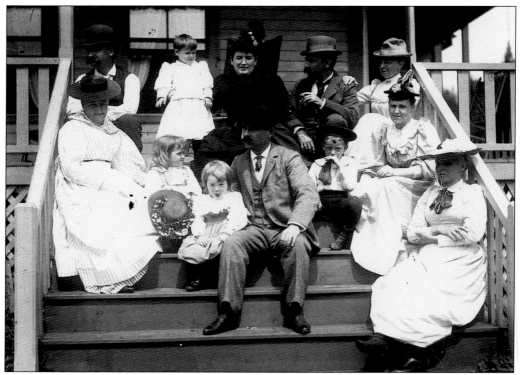

VISITING RELATIVES. Pictured here are Chick family members who came down from Maine in the 1890s to visit their Sprague cousins. Summer still brings visiting friends and relatives to Cape Cod. (Courtesy of James Calvin.)

AT REST. Two Barnstable women are reading and taking their leisure in the 1890s.

Seven
ANY QUESTIONS?

A puzzle wrapped in an enigma
surrounded by a mystery.

—Winston Churchill, referring to Russia

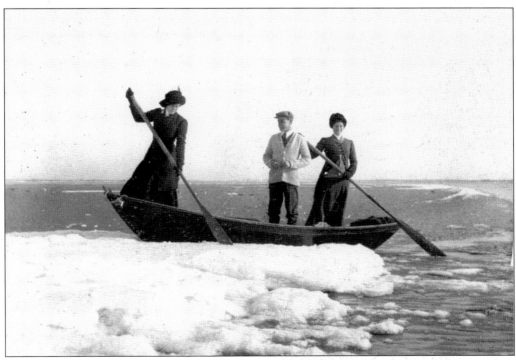

THREE IN A BOAT. It is December 1910, and we can probably assume that these three made it safely home. (Courtesy of Donald Griffin.)

THE LADY AND THE PARROT. It would be interesting to know the story of this photograph from 1888 or 1890. Parrots were not native to Barnstable, and pet shops were not common. Unfortunately, the key to unlock this mystery has been lost. (Courtesy of the Sturgis Library.)

WHO IS SHE AND WHAT IS SHE DOING? Even a fine history like this must leave some questions unanswered. What we do know is that this photograph was taken *c.* 1910. (Courtesy of Frances Bush-Brown.)